Art Classics

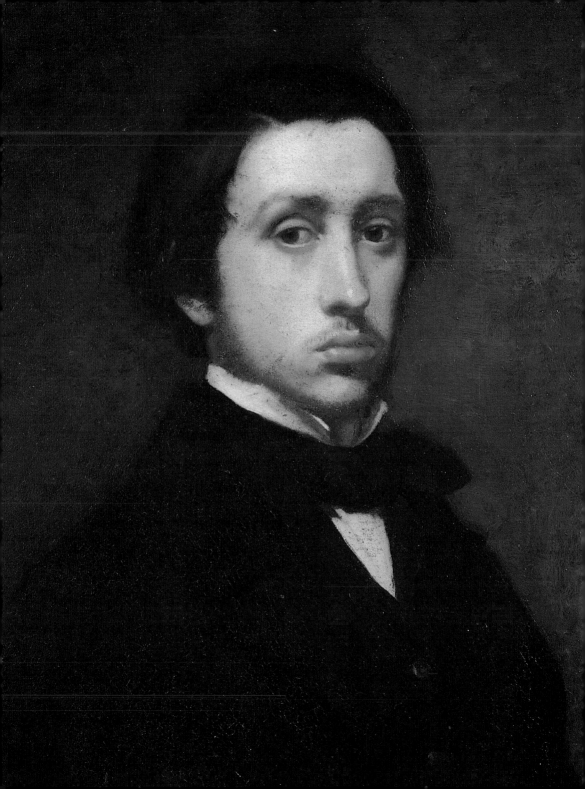

Art Classics

DEGAS

Preface by Franco Russoli

RIZZOLI
NEW YORK

ART CLASSICS

DEGAS

First published in the United States
of America in 2005 by
Rizzoli International Publications, Inc.
300 Park Avenue South
New York, NY 10010
www.rizzoliusa.com

Originally published in Italian by
Rizzoli Libri Illustrati
© 2004 RCS Libri Spa, Milano
All rights reserved
www.rcslibri.it
First edition 2003
Rizzoli \ Skira – Corriere della Sera

2005 2006 2007 2008 2009 /
10 9 8 7 6 5 4 3 2 1

Printed in China

ISBN: 0-8478-2730-5

Library of Congress Control
Number: 2005921999

Director of the series
Eileen Romano

Design
Marcello Francone

Translation
Carol Lee Rathman
(Buysschaert&Malerba)

Editing and layout
Buysschaert&Malerba, Milan

cover
The Dance Class
(detail), 1871–1874
Paris, Musée d'Orsay

frontispiece
Self-Portrait
(detail), 1854–1855
Paris, Musée d'Orsay

The publication of works owned by
the Soprintendenze has been made
possible by the Ministry for Cultural
Goods and Activities.

© Archivio Scala, Florence

Contents

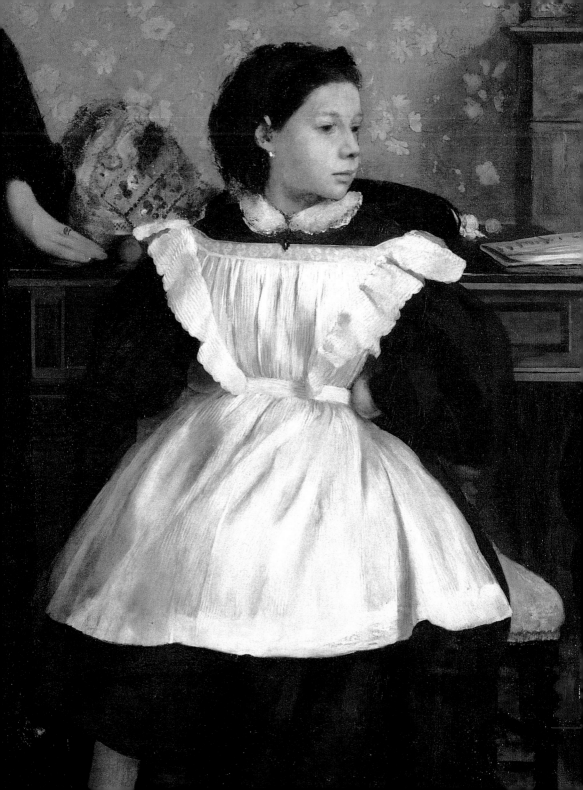

Reality Style
Franco Russoli

Degas said that it was necessary to "bewitch the reality," a principle not to be interpreted in esoteric, mystical, or symbolist terms. Use, rather, Parnassian terms, as Paul Valéry said: that is to say, achieve reality in style and style in reality. The act of poetic bewitchment can thus only consist in the metamorphosis into a unique and absolute subject of the random given: making the present eternal, translating its image into form, leading it from the existential dimension of time to the aesthetic one of space.

"Poetry is the most genuine thing there is, what is totally true only in another world," wrote Baudelaire in his polemical notes on Champfleury's "realism." But the poet's irony did not spare even the fierce passion for beauty understood as the abstract elaboration of forms, as the reverence of canons and rhythms of a classical matrix, mythicized as absolute perfection by the followers of the École Payenne. A modern, romantic idea of expressing the present reality, like that of the autonomy of art and its specific values, could not espouse any position that implied passivity, either with respect to ambitions and plans of a moralistic, scientific, or political tenor, of journalistic objectivity or demonstrative ends, or with respect to canonic formulae of classical purism. The "reality" of the phenomenon in progress had to undergo a complete transfusion into the "reality" of a pure linguistic structure, of style. Each component of the natural, worldly spectacle, like each existential value had to be transferred—like every idea and invention of harmony and metrics—into the work of art by means of "correspondences," and not

through imitative transcription or reduction and abstraction into formalistic ciphers. Hopeless effort, obsessive vice, art was to be the construction of a world that, sinking its roots into existence and the tangible reality, then struck out on a distinct and parallel path of its own: a reflection artfully recomposed to different meters and values, a "trick" based on the effects of a dependent relationship, affirming the individuality and the autonomy of poetic invention. The critical conscience back then, toward the middle of the nineteenth century, formulated with dramatic lucidity the basic terms of every modern poetic, the essential moments of every one of its crises: the relationship between principle and emotion, between form and reality. The legacy of classicist thought (the self-sufficient value of forms, the catharsis of reality in the harmony of a canonic system) fused with that of the needs revealed by early romanticism (poetry as reality, imagination as truth), but at this point a new synthesis had come into sight. That is, art had to give expression and a look to the unavoidable interdependence between the phenomenal aspects of the present reality and the invention of stylistic structures. It seemed that evasion and tendentious, unilateral justifications were no longer possible: either toward the skies of Hellenic beauty, or of the proportionate humanistic rationality, either inside the flow of naturalist sensations and impressions, or in the empyrean or the inferno of illuminations and dreams, either in the illusory objectivity of a statement or in the effort of upholding an idea. History tells us that since then similar stances by artists have instead continued to exist, and what fruits they have born: but with the anxious and even angry awareness of being fanciful or instinctive initial "choices" permitting subsequent action, subsequent attempts to reach, starting from the small space of the ideological or temperamental springboard, the absolute space of an integral poetic truth, which sporadically manages to express the eternal.

Degas clearly, and rather early on, forced himself to respect the

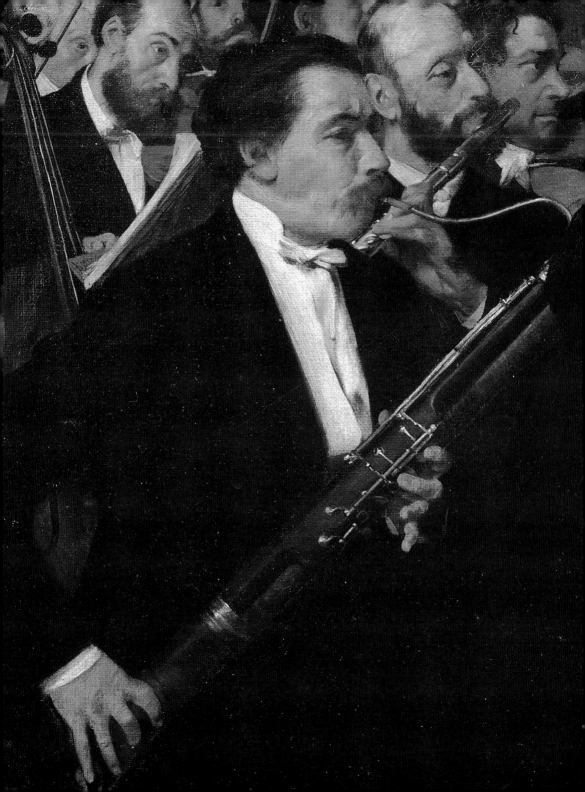

requirements and rules of art for art's sake, not as an escape or rejection of the vital compromises of reality and the human condition, but as the guarantee of an exploration and arrival at a new awareness of reality and the expression of it, carried out without equivocal confusion of terms, using specific instruments and the autonomous values of artistic language. Thus, he took on the operative condition and the final outcome of every aesthetic activity, everywhere and always, out in the open, and set, with lucid determination, as the starting point, as the "poetic" of his expressive task. After the period of heated battles between apparently opposite artistic ideals, and before the fatal use of many and different approaches to tendentious and radical poetics (after the *querelles* between classicism and romanticism, Parnassus and realism, before the desperate or dogmatic gushing into the streams of scientific neoimpressionism, symbolism, vitalism or mysticism entrusted to the evocative power of abstract forms), Degas based his work on the awareness of his own specific task as an artist: to communicate the message of things through the structure of their forms. Thus, he put into practice the principle of art as life, since only in the pursuit of self-contained stylistic values in the spectacle of nature, and in ridding the work of art of every superstructural relation with other significances and dimensions of being, and only in the rejection of every ideological, sentimental, or technical suggestion, would he have carried out his purpose in life. For this reason, he made himself become, with resolute determination, the "notary," impervious to any stimulus outside of his fate, as Van Gogh remarked, astonished. He was the notary who drew up the poetic deeds of his own time, in strict conformity to the standards of the artistic code. And a notarial deed of this sort is true to the universal rule, not to the letter of convention. Degas was faithful to reality as he was to the traditional terms of the pictorial and plastic languages: that is, he had to conquer them and

transform them and defuse them from within in order to restore them, appearances and forms, with new meanings and values.

Degas's work, therefore is marked by its exploration, intelligence, resolve. The same, simultaneous obsession to observe every aspect of reality, to give it an appearance, and still at the same time to invent and develop the signs and the forms of "style" torments and regulates every single one of his acts as an artist. It is a moral outlook that, keeping in consideration the disdainful and impatient facade that he erected to try to hide his reserve and anxiety, is revealed by Degas's famous affirmations: "No art was ever less spontaneous than mine. What I do is the result of reflection and study of the great masters; of inspiration, spontaneity, temperament ... I know nothing. " Or: "Art is the same word as 'artifice,' that is to say, something deceitful. It must succeed in giving the impression of nature by false means." And Valéry correctly noted that, "for Degas, a work was the outcome of an indefinite number of studies, and then, a series of operations." It was reality, then, taken as a whole, in every aspect as it appeared in the artist's everyday experience, in his circle of acquaintances, his habits and inclinations as a rich, cultured man, a part of the aristocratic upper class: portraits of family and friends, the theater, dance, racing greens, the cafés, and the models used as nothing more than animals in the free state, material for observation and study. An undifferentiated repertory, from the point of view of symbolic aims and literary and didactic content: nothing but life as it appeared to Degas, and as he wanted to render it intact in the "other" dimension of artistic structure. The moment of the "reflection" in an image, as faithful as possible to reality, overlapped with the moment of the "process" of stylistic metamorphosis, aimed not at extracting certain special meanings from those appearances of reality, or making them mere supports for formal harmonies, but at capturing its mysterious vital essence, presence in itself.

A spectator who looks on impartially at the game of life, and who recreates the moves on the structural chessboard of style, Degas does not have with respect to such a show—in which he is nevertheless involved, as a man—any celebratory or protesting aim when he is acting as artist. In this, more than in the specific characteristics of the language, he resembles the impressionists: he avoids any suggestion, any involvement that is not of a stylistic order, he refuses to let art submit to any purposes extraneous to it. Thus, Degas accepts all together, as a poetic world, his upper-class world, with all its rules and its conventional values as a social system. Like Monet and Renoir, Degas looks at and translates aspects of reality, without subjecting them to theories or projects. His temperament (despite all his efforts to overcome it) and his cultural background lead him to prefer the spectacle of human society over that of nature; and, at the same time, his stylistic education—let us not forget his apprenticeship with the native of Lyon Louis Lamothe, follower of the academic Ingresism of Flandrin—reinforced his tendency to choose stylistic solutions more based on the graphic framework and patterns of color zones, than on the atmospheric fusion of tonal values or timbres. Given these substantial differences, the fact remains that Degas could still feel that he was a participant and protagonist of the Impressionist "secession" for reasons of ideological choice and not linguistic tendency.

Degas is an "eye" that reflects the tangible reality, but the reflection that he offers is an invention caught in "dimensions" invented according to the rules of a non-naturalistic—indeed, highly intellectual—spatiality. His work, whether painting or sculpture, seems to reproduce analytically, photographically, a moment of life lived through, and it is instead a construction based on standards and values "other" than those of the optical impression. Behind the seeming immediacy of the casual layout, captured live, there is concealed a "series of processes" of sliding, placement, connections between the various parts, that all

following
pages
*The Parade
(Race Horses
in front of the
Tribunes)*
(detail),
1866–1868
Paris, Musée
d'Orsay

13

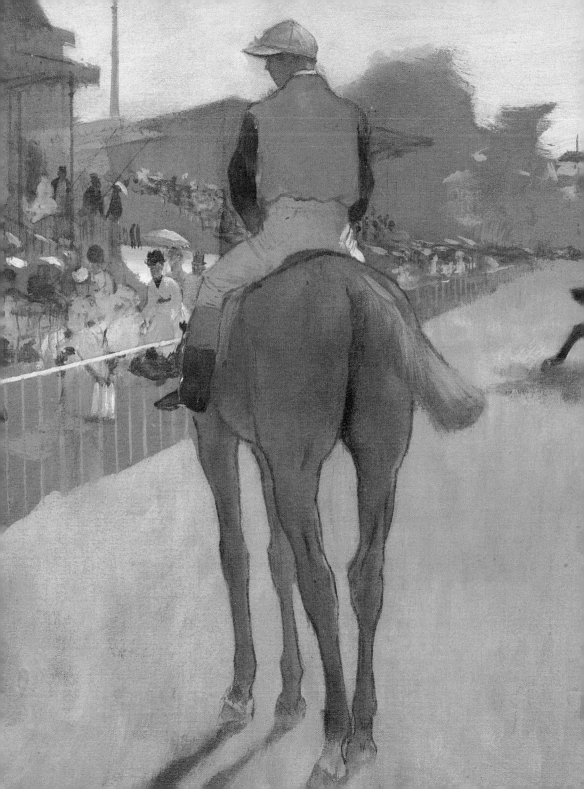

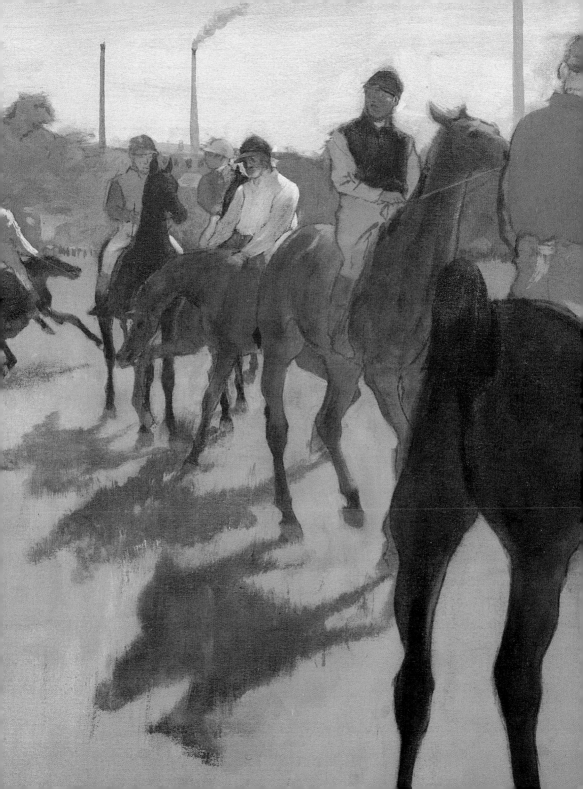

contribute to the dazzling result highlighting the vital gesture, in a moment of crystallized illumination. A "chessboard beyond the mirror": this is the peculiar nature of Degas's Baudelerian imagination. If he chose as his subject the present-day reality, "modern times," and early on he abandoned the mannerist reconstructive figuration of historical events and myths, he did so because his commitment and his wager to break down the resistance of "reality" in the game and in the deception of art were so absolute and dramatic as to offer no alibis and no way out. This choice was not temperamental in origin, nor did it have to do with content or controversy; its motivation was specific, that of an artist: a challenge to the hazard of lapsing into trompe-l'œil, the genre scene, or at the opposite end, the exhibition of pure quality and formal mastery. Remember Degas's harsh judgment of Manet in 1882, whom he nevertheless admired: "Manet bête et fin, carte à jouer, sans impression, trompe l'œil espagnol, peintre…" Painterly-painting, like literary painting, does not attain the absolute of art.

Thus, Degas chose the chance subject, the phenomenal material at hand, since it has no other basis for interest apart from its "being": not because it suggests emotions, evocations, reactions. It is a story without a plot and without a message. The object and the event are myths and symbols of themselves; they have in their presence the elements of their beauty and immortality. And, captured and isolated in their basic, nude appearance, but keeping within the space of the artistic instinct and in the poetic meter of the formal rules, here they are reaching the peak of vital energy. The analytic obsession and the harmony of the composition—the lightning-like capture of the *tranche de vie* that then shows itself to be the culmination of a thoughtful structural synthesis—did not stem from ideas of verism or from intentions to encapsulate reality in the wrapping of form and rhythms of canonical perfection. They are ways to bring into focus the privileged moment in which the existential

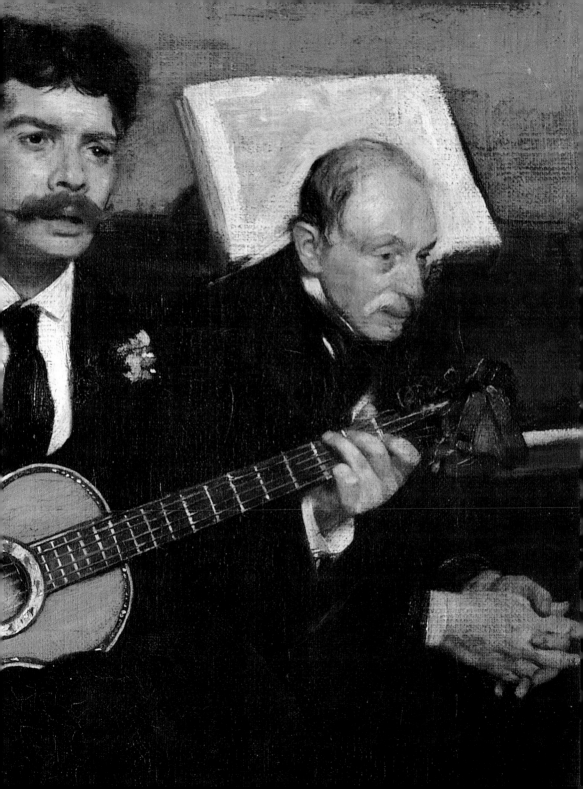

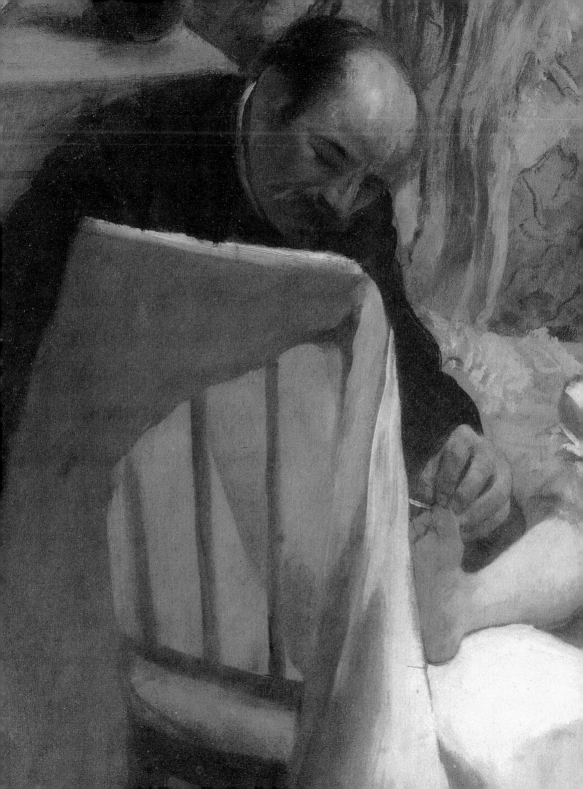

becoming (a gesture, an expression, a state of mind) is halted in the eyes of the poet to be transformed into an aesthetic moment.

If we think back to the historical and mythological scenes, from the *Young Spartans* to *The Suffering of the City of Orléans*, we see in them not only the tribute paid to the iconographic conventions of classicist purism or troubadouric romanticism, but precise signals of the new intentions and intuitions. The compositional rhythm is disarticulated, fragmentary: the scenes do not harmonize with one another in an enclosed space, the actions are not connected between themselves by relations of pure formal metrics, nor do they settle into a narrative unity, but are juxtaposed like moments frozen in the continuity of facts and natural places, that begin and go on outside of the temporal limits of the episode and the spatial limits of the painted surface. In these paintings there is a dramatic and contradictory tension, stemming from the attempt to combine the closed form, closed in the classical sense (the volume, the outline, the color of an image connected and crystallized in a rational harmony), with the continuous flow of a living reality, plunged into its existential becoming. It was the everlasting ambition and torment of Degas, who wanted to keep those paintings of a literary and historical subject in sight, even when he had abandoned such themes for the "modern subject." The change of illustrative content, the abandonment of the courtly composition for one of "modern life" or spontaneous, everyday acts, did not shift the terms of the problem: and a meeting of cotton merchants in the modest room of the New Orleans market was to be the *Apotheosis of Homer* of the highly devoted admirer of Ingres, who looks to the present for the golden standards of a harmonic, not purely visual, structure.

Degas wished to bring spectacle into life, from the "animal" gesture to the setting and contemporary social behavior (the "human comedy" of Balzac, the Goncourts, or Zola), into the classical showcase of an objec-

19

tive and crystalline style, for which the names of Mérimée, Gautier, and the heroic torment of Flaubert and Baudelaire come to our aid. Even the transformation of the technical language that Degas brings about in the last decades—from the clean incisiveness of the line, and the color zoning, to the swirling and feathery flow of the masses blended in the luminous space, but always expressed in essential, synthetic gestures— is consistent with that fundamental focus. Degas changes technique (just think of the pastels, the monotypes, the sculptures) so that the tool corresponds with his diminished eyesight, leading, however, to the same results in terms of stylistic approach. It is the same flash of the instant in the eternity of the formal rhythm, that he gives us in those fluid color masses, soft, but all of a sudden lit up by intense hues, graphic articulations, and nimble colors that place the figures in a fantastic dimension, and make them absolute and immutable. Like the world of Phidias that conserves its Olympic stature in the blurring of a flash. Renoir recalled one of Degas's drawings of a nude, a charcoal sketch, describing it as "a fragment of the Parthenon." Obviously not for the repetition of a classicizing component (he who, in such a different way, had provided his modern interpretation of Ingres), but for the rigorous and fresh harmonizing construction that recalls the pure beauty of the forms, as spontaneous, as chance, and as unexpected as in the spectacle of nature.

To interrupt the existential cycle of the scene and extract the moments of the most intense formal synthesis, and overturn the canonic order of a purely rhythmic and classical beauty to give blood and sinew to human forms of energy and pathetic effort: these perhaps are the opposite terms within which Degas carried out his brilliant and dramatic "modern" quest. Seen in this light, we can understand the revolutionary importance of his uninterrupted studies from the past, his copies, his obsessive plumbing of the style of the old masters, in order to discover in them the path that led them to blend nature and the reality of their

time with the absolute of a harmonic form. Seen in this light, we understand the continuous studies from life, the exploration of routines, physiognomies, psychologies, on impersonations, attitudes, and spontaneous gestures, captured as they happen, like frames from a motion picture. And then we can see that the true legacy left by Degas does not lie in the stylistic formulae and iconographic choices of Mary Cassatt, Zandomeneghi, Forain, nor so much in Toulouse-Lautrec or in Gauguin and in Picasso, but in the anxiety and the obsession alive in other artists of our time: from Munch to Vuillard, Sickert, Bacon, and on to Giacometti. It was Giacometti who expressed an idea that Degas may not have been unhappy with: "It's exactly the details that make up the whole... that make up the beauty of a form."

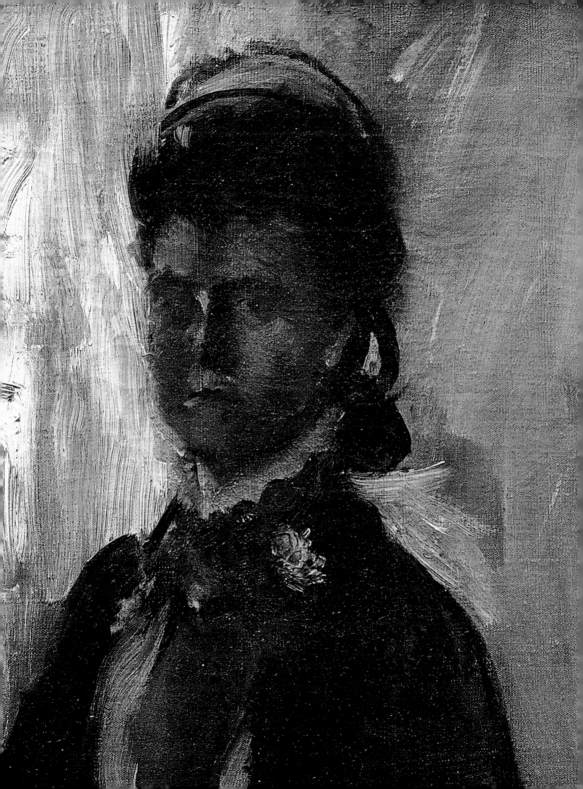

His Life and Art

"Degas always felt that he was alone, alone in all possible kinds of solitude. *Alone* in his temperament; *alone* in the uniqueness and the particularity of his nature; *alone* in his integrity; *alone* in the dignity of his rigor, in the inflexibility of his principles and ways of thinking; *alone* in his art, that is, in what he demanded of himself. […] Some explorations, immensely difficult ones, can isolate whoever delves into them. This isolation can be imperceptible […]. A part of this individual's mind can certainly be engaged in responding to the *others*, and even shine in their respect; but, far from being confused with that self-forgetfulness that generates an exhilarating exchange of similarities of impressions and contrasts of ideas, here he withdraws through this same exchange, which makes him feel even more distinctly his isolation. […] Thus, in reaction, a second loneliness takes shape, where he needs to feel himself secretly, studiedly, aggressively without compare."

From his youth, Degas had always been a solitary artist, difficult, introverted, completely caught up in his own art, his only purpose in life, at the expense of human relations and affection. Toward the end of his life, this trait gradually caused him to be broken in spirit, leading him to plea for the help (and sometimes the forgiveness) of the few friends left him, those who had had the courage to stand by him, who had perceived, underneath the pall of eternal dissatisfaction, bitterness, and anxiety, the greatness of the upright and incorruptible man, and the brilliance of his artistic mastery.

Paul Valéry, one of the few to whom Degas addressed his art, was a friend of the artist and an unstinting admirer of his intellect. He dedicated an essay to the painter entitled *Degas, Danse, Dessin* ("Degas, Dance, Drawing"), which has a merit that few writings on art can claim, that of letting the reader discover Edgar Degas, the man and the artist, as portrayed by this extraordinary man of letters. Thus, notwithstanding the enormous

mass of literature on Degas, this is the source for most of the opinions expressed here about the artist's work.

The first of five children, Edgar Degas was born in Paris on July 19, 1834. His parents, Auguste de Gas (this is the correct spelling of the family name, which the artist later changed) and Célestine Musson, were married in 1832. The artist's father, the director of the Paris branch of his father's bank, descended from an aristocratic Breton family transferred to Naples during the French Revolution and thence to Paris; his mother Célestine came from New Orleans. Auguste de Gas was a cultured and refined man, and had a passionate interest in music and art; he regularly visited the great collections brought to France during Napoleon's campaigns.

Edgar Degas spent his early childhood in Rue Saint-Georges, near the Jardin du Luxembourg. In 1845 he enrolled at the Lycée Louis-le-Grand in Rue Saint-Jacques, where he had as his schoolmates Paul Valpinçon, the son of a prominent collector, and Henri Rouart, who was to be a lifelong friend. After lycée, he started law school, and received his baccalaureate on March 27, 1853, more to satisfy his father's wishes than by natural inclination, as his firm desire to study painting had matured during these years. Indeed, just a few days after completing his studies, he got permission to make copies at the Louvre and, almost immediately, joined the studio of the then-famous painter Félix-Joseph Barrias, who started him on making copies of nudes, and later introduced him to history painting. At the same time, the young artist continued making his copies of the works of the medieval artists conserved at the Louvre, and of the Renaissance painters that his father had first pointed out to him.

In these years (1853–1861), the budding artist focused on fifteenth- and sixteenth-century masters, without, however, overlooking such seventeenth-century artists as Holbein and Van Dyck, and nineteenth-century artists the likes of Delacroix, David, Ingres, and Daumier; among his contemporaries, he

observed Whistler, Menzel, and Meissonier. The fact that he was registered at the Louvre as "copyist" as early as April 7, 1853 demonstrates Degas's precocious career.

After initial resistance to his son's decision to dedicate himself to painting, his father, a man of great sensitivity, intuited Edgar's talent before it was obvious, and gave him full support. Indeed, he ensured that his son went to a studio that was not just interested in sterile executive performance, but was informed by a lengthy meditation on the masters of the Italian tradition, whom Auguste knew and admired. "You examined the delightful fifteenth-century masters of the fresco, you studied them well," he was to say later to his first-born son, "You slaked your spirit with them; did you make drawings or instead watercolors of the works to commit to memory their hues? And Giorgione, did you study his colors, accompanied by such beautiful draftsmanship, such elegance—did you steep yourself in it?" From these words, radiating elegance and warmth, one can imagine the special atmosphere Degas enjoyed within the domestic walls, from his earliest childhood.

Perhaps dissatisfied with Barrias's teachings, the young artist began to study painting under Louis Lamothe, who had been a disciple of Flandrin and Ingres. Thanks to Lamothe, Degas was introduced, even if indirectly at first, to Ingres and his experiences, one of the most striking encounters of his youth.

In 1855, by now brimming with a keen interest in art, he applied for entrance to the École des Beaux-Arts, and obtained admission to the most prestigious French academic institution in the area of fine arts. However, his early vocation to self-learning made him tire rather quickly of the rigid didactic methods employed by the École professors. The myth of Ingres grew in the young man's heart, so that one day he begged the collector Valpinçon, a family friend, to introduce him to the great artist, whom the former knew well as owner of the celebrated *Bather*. In 1855, accompanied by Valpinçon, he finally paid a visit to the master of Montauban. When he

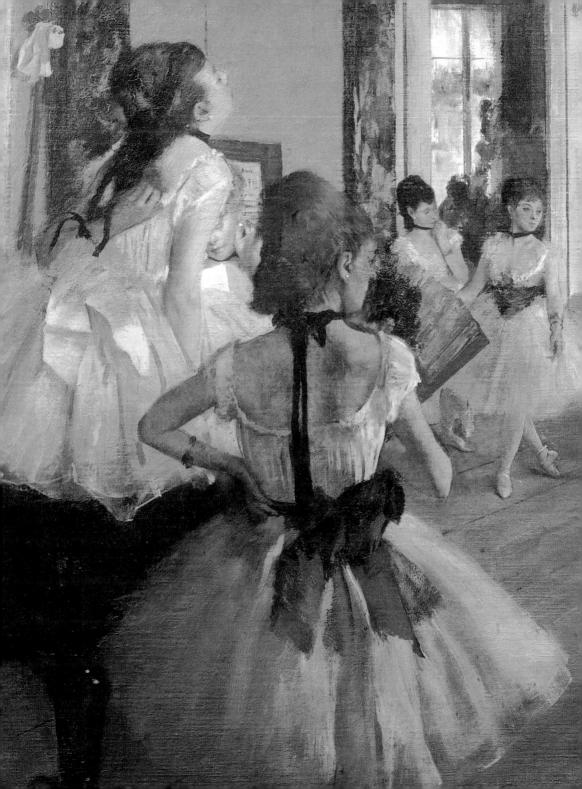

was old, Degas often repeated the story of this encounter, sometimes offering different accounts of the event. The fact is that, even in later years, when his ideas about art had changed, matured, and he had taken his distance from what Ingres advocated, Degas still held dear the memory of his youthful enthusiasm, when, although always keen to see the old masters' work, he already sought to make choices about which contemporary ideas to follow.

Ingres's precepts about art converged with young Degas's natural tendencies. The master of Montauban maintained an absolute and immutable idea of beauty, which had to be achieved through study of both *eternal beauty* (that is, the study of classic paintings) and the *natural* (that is, working directly from a model, whose forms, however, had to filter through a process of purification of the many beautiful imperfections one finds in nature). This process of catharsis of the form can only be achieved, according to Ingres, if the artist who observes nature has within himself a lofty concept of ideal beauty, at the source of which he purifies the imperfections found in creation. "The infinite models that nature continually offers us" should be interpreted "with all the sincerity of our hearts," and ennobled "by that pure and unfaltering style without which no work is beautiful." "The study or the contemplation of artistic masterpieces should serve to make the study of nature more effective and easier, and not something to avoid, because all perfection derives and finds its origins in her. [...] It is in nature that one can find that beauty that is the greatest aim of painting: it is there and not elsewhere that one must seek it. To make an idea of a different beauty, of a beauty superior to that found in nature, is as impossible as imagining a sixth sense." Ingres's ideas hark back to enlightenment sensualism and the empirical approach that was adopted in the eighteenth century as the preferred method for scientific analysis (so that Ingres asserts that one must refer to nature, understood as the great book of knowledge), and they draw strength from the prin-

ciple, at first neoclassical and later romantic, that art must serve as an example. Therefore, from this assumption stems the idea that the artist must interpret "with the sincerity of his own heart," that is, with his own moral and intellectual rigor, the examples taken from the "old masters" and from the "infinite models offered by nature."

From a practical point of view, Ingres greatly stressed the priority of the drawing with respect to color, and considered the habit of constant practice fundamental: "Draw with your eyes," he said, "if you cannot draw with your pencil." Furthermore, he considered drawing an intellectual means for grasping "the precise forms" of nature, the instrument whose function is primarily cognitive within the context of exploring the world through painting. These precepts, which Degas abided by and deeply assimilated during his years of training, were later to shape his unique interpretation of impressionism. He placed himself "on the fringes" of the new doctrine, which, in some respects, remained foreign to his

unique sensibilities. We shall return to this topic later, but for now we shall focus on Degas's other great challenge: his constant self-comparison with the masters, which at times created in him "very bitter and very noble feelings," caused "by the yearning for secrets that he attributed to them, and by the constant presence in his mind, of their contradictory perfections."

Perhaps to further his studies by making copies of the paintings of the old masters, the artist decided to go to Italy for a visit that initially, in agreement with his father, was to be rather brief, but then stretched on for nearly three years.

On July 17, 1856, Degas put in at Naples, where he was the guest of his paternal grandfather René-Hilaire, whose splendid portrait he made. From Naples, he moved on to Rome, and stayed there for nearly two years; then, from August 1858 until spring 1859, he was in Florence. Meanwhile, he made a few brief

excursions to become better acquainted with the magnificent fresco cycles conserved on the peninsula. He went to Perugia, Orvieto, and Assisi, where, standing before Giotto's decoration of the basilica of San Francesco, he wrote: "I have never been so moved, I cannot stay here, my eyes have filled with tears."

Many years later, whenever asked for advice about art, Degas said: "You have to copy and copy again the work of the masters, and only after having passed all the tests of a good copyist, can you reasonably dare to paint even a radish from life."

The outcome of these painstaking studies led him to believe briefly that the artist's craft required an energy and a determination superior to his own, so that he contemplated renouncing a career in an occupation that could only cause him anxiety. He confided his doubts to Gustave Moreau: "Remember the conversation we had in Florence about the sadness of whomever works at art? When you said that there was less exaggeration than you thought. In effect, this melancholy has no

29

relief. It increases with age, and no consolation is provided by progress and youth, except a bit of illusion and hope."

To examine the theme of copies is useful for grasping, with a single glance, the poetic thread that unites Degas's entire oeuvre, from his early years to his old age: that is, a certain mindset, so sensitive to citation that it led him to reflect continually on how the great masters approached the problems of representation in painting.

Degas used various criteria for executing his copies: some are merely minimal, highly synthetic sketches, such as the copies from Benozzo Gozzoli's fresco cycle in the Campo Santo at Pisa, which may have helped him set down on paper the essential memory of the frescos; others are, instead, copies of a fragment; and yet others are variations on an old theme, a practice widely used in the nineteenth century.

Having to reproduce the paintings of old masters, Degas was forced to tackle the complex study of artistic techniques that such artists used, whether for drawings or for paintings in oils or temperas. Renaissance painters did not use drawing techniques that were common in the nineteenth century. For example, in early fifteenth-century Florence, drawings in what is known as "pencil" (*matita*) were very rare, and did not become widespread until the sixteenth century, though the tool was not the graphite one we know today, also called *lapis*; instead, it was made with a red or black chalk mineral, which, in the case of the Florentines, was extracted from the quarries on the isle of Elba. So, up until the sixteenth century, artists used pointed styluses made of such soft metals as lead, tin, or silver that left a very fine, permanent mark on the paper. In 1858, Degas often used leadpoint. In addition to copying the paintings of Italian masters, Degas used the old technique of drawing on colored paper. He used this support to do copies from Beato Angelico, Mantegna, Botticelli, Paolo Uccello, Gentile Bellini, Michelangelo, and Daniele da Volterra. In some cases he applied white lead high-

lighting on a leadpoint drawing, just as the old masters did; other times, he made oil copies, as in 1858–1859, when he copied Pontormo's *Portrait of a Girl* at the Uffizi, which we can interpret as an exercise, or as a variation on an old theme.

During the time he spent in Rome, the artist attended Villa Medici, an institute for the study of fine arts that was also a hostel taking in students, young artists who, thanks to scholarship funding, found their way to Rome from France to study the old masters. In this aristocratic art school, it was common practice to paint the nude model directly from life. At Villa Medici, following Ingres's years as headmaster (1835–1840), the school of nudes remained open to the public through the evening, and even took in artists who were not enrolled at the institute. Degas was a habitué of this milieu, where he met Gustave Moreau, the future exponent of French symbolism. Degas often went together with Moreau to the Caffè Greco, where Italian and foreign artists mingled; here he met and made friends with the sculptor Aristide Maillol, the painter Léon Bonnat, and the musician Georges Bizet.

In 1858, Degas moved on to Florence, where he was the guest of his aunt and uncle Laura and Gennaro Bellelli, who had two children whose faces show up in a few folios of this time. Before moving to Florence, he had sent some drawings to his father, who was enthusiastic about his son's evolution and encouraged him with loving praise. Auguste wrote his son: "You have made great strides in art […], your drawing is effective and your coloring is right. […] Work with confidence and continue in this direction, I say, and you can be sure you will do great things. You have a fine future ahead of you; do not get discouraged, do not trouble your soul."

At Florence, he met up with Gustave Moreau, and together they frequented Caffè Michelangelo in Via Larga, a meeting place for the Macchiaioli. When his friend left, Degas grew very bored in Florence, but he stayed on because he wanted to see his aunt Bellelli, who had traveled to Naples because

of the death of grandfather Hilaire, of whom Degas was quite fond.

During this time in Florence, the artist started to sketch his portrait of the Bellelli family, which he did not finish until 1867, after a good nine years of gestation. After all, we can grasp exactly what he means about the slow and complex formation of a painter: "Isn't it true, my dear Moreau, that there is the opportunity to create light, beauty, feeling, drawing, and color with great love for what you are doing, with the desire to learn and a deep belief in the *excellence of painting* (as Vasari puts it)?"

The more you learn about the young Degas, the more you discover how focused, curious, refined he was, "a perfect man of letters," as Paul Valéry described him, though the artist could not abide men of letters, did not like dissertations on aesthetics, and could not tolerate critics, especially if they discussed his paintings.

When he returned to Paris, in the spring of 1859, after his visit to Italy, Degas started to paint some canvases of an historical subject, and he continued working at the same time and for many years to come on the *Bellelli Family* portrait He dedicated himself to the history pictures starting in the early 1860s. His devotion to the old masters and the literary inspiration of these works merged, from a practical point of view, with his adoption of a style that had strongly naturalistic traits. From 1860 to 1862, he painted the *Young Spartans* and *Semiramis Founding Babylon*. The subject of the *Young Spartans* had been inspired by Abbé Barthélmy's *Voyage du jeune Anarchasis en Grèce*, published in 1787. In the text, widely taught in such traditional schools as Lycée Louis-le-Grand, where Degas had studied, it describes how, "Girls in Sparta were not educated as in Athens. They were not kept at home to spin yarn, and it was not forbidden for them to drink wine and eat abundantly. To the contrary, they were taught to sing, dance, and fight, to run on sand, throw the javelin, play on the rings, half-naked and unveiled, in the presence of magistrates, citi-

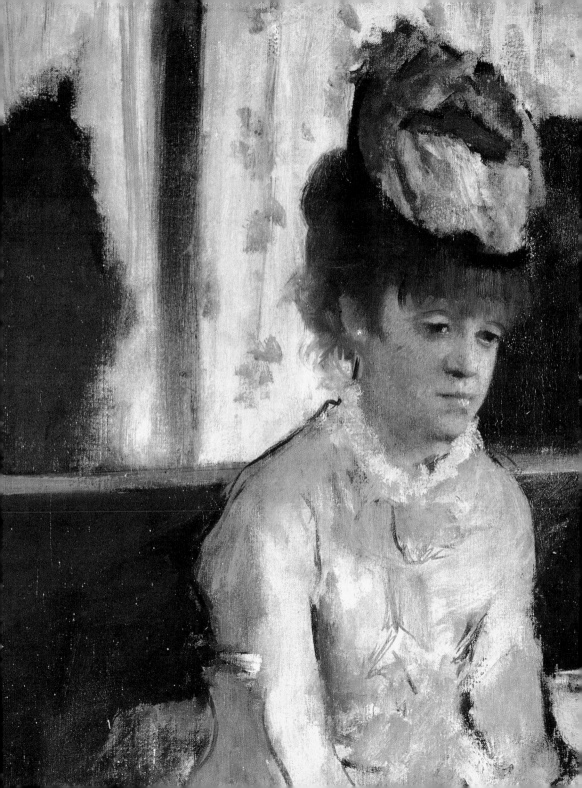

zens, and even children, whom they incited to glorious deeds, both through their own example, and through their sweet words of praise." Degas handled the subject with a formal sobriety that was well matched to the literary text. He worked out the composition by structuring it according to a strict symmetry that recalled neoclassical rigor, even in the frozen poses of the figures (a few years earlier, he had copied David's *Death of Bara* conserved at the Musée Calvet at Avignon). The nudes, however, were handled in a naturalistic way, and the faces were not a repetition of a physiognomic idea (as instead occurred in the painting of the First Empire), but portraits done of models, each one of which shows a different expression. The color, applied in broad zones, exquisitely harmonious and without excess or glaring effects, is contained within a strict line that shapes and defines the outlines of the figures; this style holds an obvious homage to, in addition to the frescos of the Italian primitives, Ingres's painting, particularly the motionless poses and the state-

liness of such works as *The Apotheosis of Homer*, a picture that Degas much admired.

The painting *Semiramis Founding Babylon*, instead, takes its inspiration from the story of Diodorus Siculus, published in France in 1851. We can mention as sources for the work, though without any order of priority, Gioacchino Rossini's *Semiramide*, staged at the Opéra in 1855, and the important archaeological finds following which Assyrian, Greek, Egyptian, and Etruscan artifacts flowed into the French museums. Having at disposition such a wealth of works must have been a major influence in deciding the subject matter of so many French paintings of the nineteenth century.

In these years, Degas's creativity was inspired by his friendship with the cultured and sophisticated Gustave Moreau, with whom he shared a melancholy and nostalgic attitude toward the art of the past. We can see this frame of mind in Degas's letter to his friend Moreau after he saw the work of Van Dyck: "In this great genius there is more than one

natural tendency, as you, my dear friend, told me yourself one day. I think he reflected at length on a subject, that he steeped himself in it, like a poet." This reflection on the man of genius and his art as a consequence of a unique sensibility recalls the romantic, dreaming outlook that art criticism took on at the moment of its inception. Far from seeking to propose connections with readings we do not know whether Degas had done or not—in fact, he was hardly receptive to artistic theory—the reference is meant to show the spirit of the ideals that fueled the era in which he lived, sharing with others of his same century attitudes that we are hard put to interpret correctly. The nineteenth century was a time permeated by sentiment, and this outlook led the intellectuals to elaborate a highly emotional relationship with reality. It suffices to think of the evolution of the novel: "In its own way, according to its own logic, the novel discovered, one after the other, the different aspects of existence: [...] with Balzac, it discovers how man is rooted in history; with Flaubert, it explores the to-then uncharted territory of the ordinary; with Tolstoy, it examines the role of the irrational in human behavior. The novel plumbs time: the elusive moment in the past with Marcel Proust; the elusive moment in the present with James Joyce. It probes, with Thomas Mann, the role of myths which, having come from the beginning of time, guide our steps from afar. And so forth." (Milan Kundera, *The Art of the Novel*).

The fact that at a certain point Degas decided to abandon the subjects taken from history and ancient literature in order to concentrate solely on the representation of contemporary life does not at all imply a rejection of the literary component, but rather a meticulous updating of the issues taken up by the French realist movement, which had started up sometime around mid-century, and continued to express its ideas in an increasingly programmatic way. Very probably a factor in Degas's about-face in his art was his encounter with Édouard Manet. Degas was at the Musée

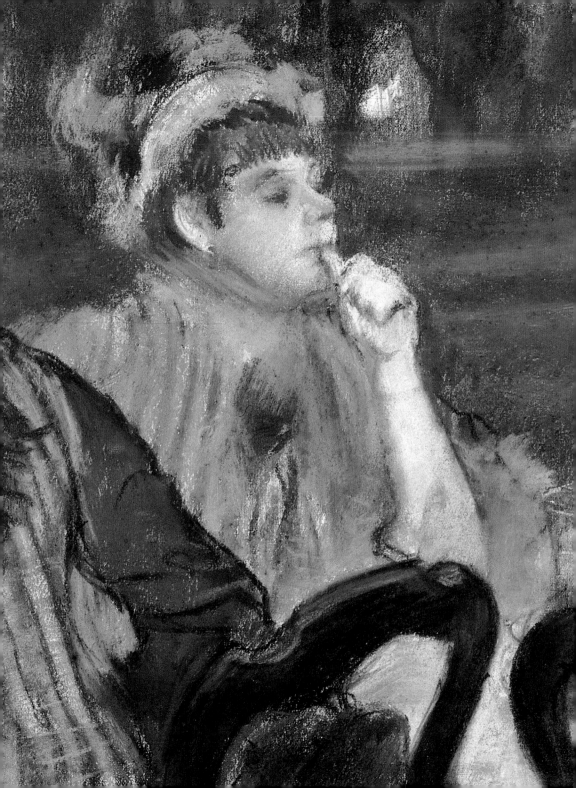

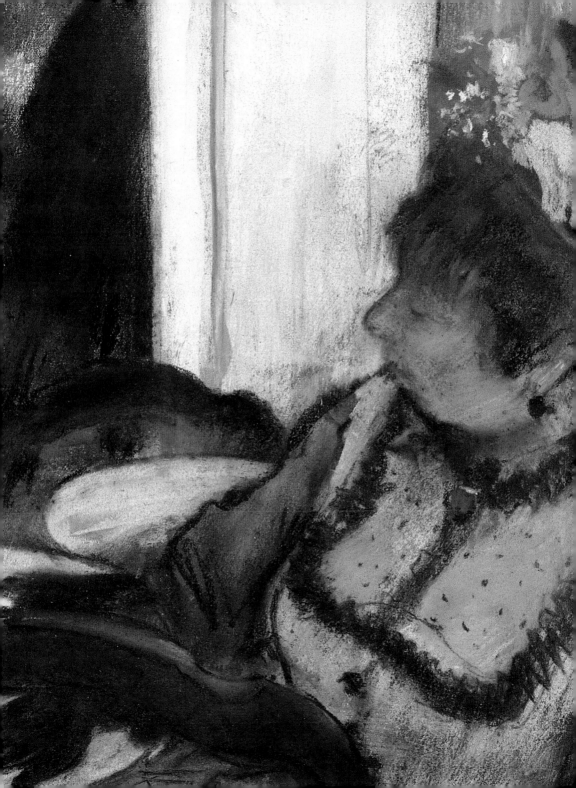

du Louvre, working on a copy of Velázquez's *Infanta Marguerita*, and he met Manet, who was in the same room. Manet aroused a great sensation when he displayed such a "scandalous" work as *Le Déjeuner sur l'Herbe*. The year was 1863, and the exhibition venue was the Salon des Refusés, that is, the salon of painters rejected by the official selection carried out by the jury. Since that year saw the rejection of the work of a good 442 artists, some of whom actually enjoyed the favor of Empress Eugénie, the resentment of the refusés could not be contained. Thus, Napoléon III decided to designate a part of the Palais de l'Industrie as an exhibition site for the works not accepted. In Zola's novel *L'Œuvre* we find an account of the events at the 1863 Salon: "And the two youths, having crossed through the garden, went up to the Salon des Refusés. They had set it up very nicely, the accepted paintings had certainly not been hung with greater elegance: there were long draperies of antique tapestries hung in the doorways, moldings decorated with green fabric, small red velvet sofas, white canvas curtains on the ceiling windows; and the suite of rooms looked at first glance like the usual official exhibition, with the same gold frames, the same bright area of the paintings: But a special cheer dominated the scene, a youthful blast that at first was not clearly perceived. The crowd, already thick, grew by the minute, since everyone was abandoning the official Salon, running, driven by curiosity, pricked by the desire to pass judgment on the judges, amused, above all, already at the entrance, by the certainty of seeing very funny things."

The association with Manet gradually led Degas closer to Courbet's realist ideas, which within a few years' time had convinced him to paint only contemporary subjects. Gustave Courbet had published his "Manifesto of Realism" in 1861 in *Courrier du Dimanche*, where he stated, "Since I believe that every artist must be the teacher of himself, I could never consider being an educator. I cannot teach my art, nor the art of any school, as I reject the teaching of art, or in other words I

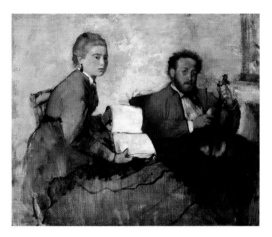

feel that art is completely individual and that, for each artist, it is nothing but the result of his own inspiration and his own studies of tradition. I will add that art or talent, in my opinion, should only be for the artist a means for applying his personal skills to the ideas and the things of the time in which he lives. In particular, the art of painting can consist only in the representation of the things that he can see and touch. Any given period can only be represented by its own artists […]. I feel that the artists of one period are absolutely incompetent to represent the things of a past or future century […]. It is in this respect that I reject the painting of historical events applied to the past. Historical painting is essentially contemporary." What we read in Courbet's passage became fundamental for Degas starting in the second half of the 1860s. For the time, Degas exhibited regularly at the Salon, even if his works went practically unnoticed, apart from a few small remarks made by the most alert and perceptive critics.

The year 1868 was a crucial moment for

Fin d'arabesque
(*Ballerina with Bouquet*)
(detail), *c.* 1877
Paris, Musée d'Orsay

the painter. He started going regularly to the Café Guerbois in Rue des Batignolles, the meeting place of artists and literary figures; there he met Renoir, Monet, Sisley, Pissarro, Cézanne, and Bazille. He also made the acquaintance of the critic Edmond Duranty, future theoretician and champion of impressionism, and the photographer Nadar. During the chats that took place at the café, the painters, led by Monet, formulated the idea of exhibiting together to dissociate themselves once and for all from the official circuit, and make themselves known as a group of "independent" artists. This idea had a lengthy phase of gestation due to the lack of funds to allocate to the organizational aspect, but it was finally realized in 1874, when the first show of the future impressionists was inaugurated in Nadar's studio in Boulevard des Capucines.

Between 1867 and 1868, Degas was working on *Portrait of Mademoiselle E. F. … in the Ballet "La Source,"* a key work, as it is the first with a contemporary ballet as its subject; the ballet was performed in Paris in 1866 by the famous ballerina Eugénie Fiocre. It is telling that the artist decided to turn his gaze from historical subjects and focus it on something connected with contemporary life, opting for a theatrical work where, in any case, the two genres, historical and contemporary, could coexist thanks to the stage invention. The painting, as the title states, is characterized as a portrait of the ballerina. It presents thematic ambiguity expressed by the fact that it cannot be considered either a portrait in the conventional sense, or an historical picture, or even a true stage scene, as no element comes forth to define the stage. From a stylistic point of view, the work shows precise choices on the part of the artist: the painting is inspired by Gustave Moreau's sensual exoticism, moderated by a composure and a scope that Degas may have picked up from Poussin, whose works the artist could have admired at the Louvre, and whose sweeping and synthetic style offered a key for imbuing on a theatrical scene with a mythical aura, without, however, betraying the aim of abandoning the historical genre.

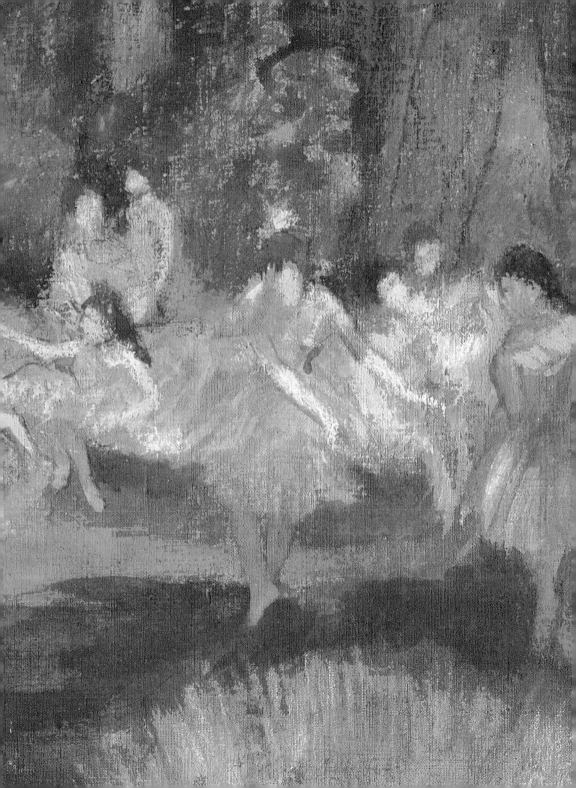

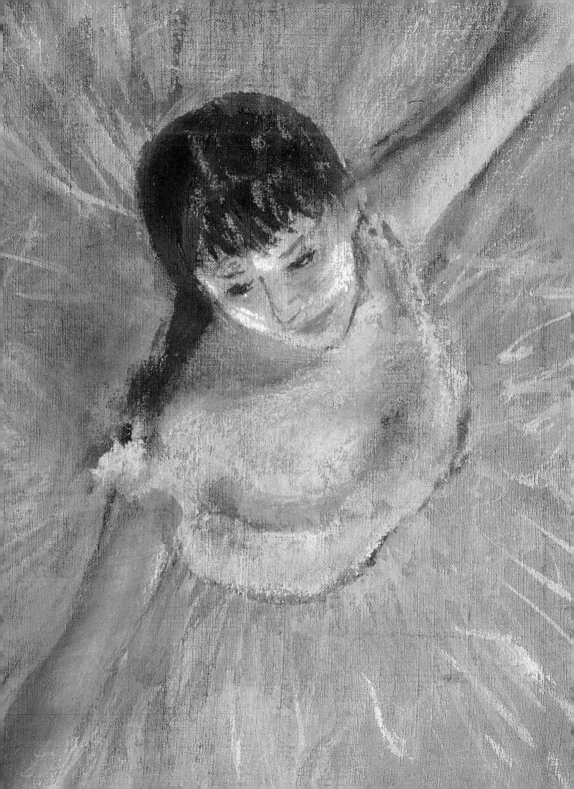

With the onset of the 1870s, Degas embarked upon a very intense period for his art. Starting now, he dealt with all the subjects that he would return to with constancy, and in the later years, serially, until the end of his painting career. As genres, they were: portraits (which he had already done in his youth), the treatment of which he would renew according to the realist criteria; the horse races; scenes from the world of the stage (including dancers, portraits of orchestras, circus pictures, Paris café music hall shows); nudes, and laundresses.

From here on in, the artist did not budge from this array of subjects, so that whatever evolution his painting underwent must be assessed within the context of the genres he returned to with ever-new curiosity.

The world that Degas explored in these years primarily has to do with the musical sphere. The theme of the ballerinas was introduced for the first time in a painting of 1868 entitled *The Orchestra at the Opéra*, depicting the theater musicians and allowing a glimpse, in the upper part of the canvas, of a ballet movement.

Meanwhile, Degas began to harbor distinct feelings of discontent about the institution of the Salon; he wrote an open letter to the members of the panel entrusted with the selection of the works, published in the *Paris Journal* on April 12, 1870, and prefaced by a brief introduction by Duranty. In the letter, the painter politely but succinctly lists the deficiencies that the Salon exhibitions showed, flaws that, according to the artist, could be corrected with just a dab of good sense. His grievances, for example, concerned the dreadful habit of displaying the canvases in three rows, leaving very little space between one canvas and the other. Furthermore, he proposed to break the rigid symmetry in the arrangement of the large marble sculptures, and to display medallions, busts, small sculpture groups on shelves and on panels.

This first, moderate initiative was

followed by the decision not to exhibit at the Salon again, since for a perfectionist aesthete like him, all in all quite unconcerned about the approval of the broad public, the treatment of the paintings admitted for exhibition must have been utterly unacceptable; unfortunately they were exposed to the gaze of very poor judges and equally shoddy tapestry-sellers. As an alternative to the Salon, he chose to work with Paul Durand-Ruel, the gallery owner and collector, from the very outset a staunch supporter of the Barbizon school, then, later, a fan of the impressionists.

Between October 1872 and March 1873, the artist and his brother René visited New Orleans, where they were the guests of his mother's relations. During his time in American, Degas did some family portraits and the famous *A Cotton Exchange in New Orleans* (also known as *Portraits in an Office*), which he brought back home with him when he returned. From Lousiana he wrote his painter friend Lorenz Frölich: "Have you read Jean-Jacques Rousseau's *Confessions*? If you have, you will remember his way of describing the true nature of his temperament, when he withdrew to the lake island of Saint-Pierre in Switzerland (toward the close of the book) and when he tells how, at the break of day, he went out and wandered here and there, aimlessly, examining everything, planning projects that would have taken ten years to complete, and which he abandoned with no regrets after ten minutes? Well, I am just like that. Here, it all fascinates me, I look at everything, I'll describe every detail to you upon my return."

On his arrival in Paris, he took up frequenting his painter friends again, whom he had left at the gathering place of Café Guerbois, and rediscovered at the Café de la Nouvelle Athènes. He took a house in Montmartre. The group of painters who gathered at La Nouvelle Athènes managed to found, in 1873, the Société Anonyme des Artistes, Peintres, Sculpteurs, Graveurs, etc., an association that was to realize the independent exhibition ideas that the group had

already dreamed up at the close of the 1860s. In the spring of 1864, the group inaugurated its show in the rooms of the photographer Nadar's studio; the event went down in history as the first impressionist exhibition. However, before the show's opening, the term "impressionist" had never been used to describe the painters showing at Nadar's place. It was the critic Louis Leroy who coined the name with the aim of ridiculing the group in his famous review "Exposition des Impressionists," published in *Le Charivari* on April 25, 1874. Degas showed ten works at the show, and sold the canvas *The Dance Lesson* to the baritone Faure for the considerable sum of 5,000 francs. Manet had refused to participate in the group show, in which, instead, Cézanne, Pissarro, Monet, Renoir, Sisley, and Berthe Morisot took part. Degas held to his intention of never showing again at the Salon, and participated in the impressionist exhibitions, forsaking only the seventh one in 1882, and returning for the group's last show, which was held in 1886.

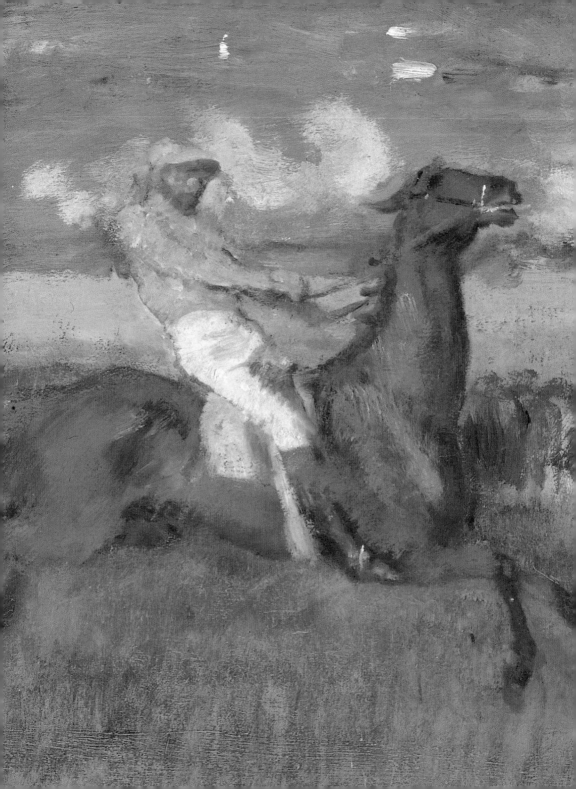

In the second half of the 1870s, ballerinas became the main subject of the artist's canvases. At first, Degas painted interiors with ballerinas who showed, in a rather conventional way, the various dance positions. As his output of ballerinas intensified, Degas's focus gradually honed in on the problem of movement, which he anxiously tried to capture, though he was continually disappointed with the results he obtained. It was the same anguish that Cézanne experienced when painting Mont Sainte-Victoire, and Monet when taking on his water lilies.

From the very beginning, the painter's interest latched onto the study of the gestures of the figures that he observed, indeed, that he surprised, not in the act of dancing, but rather in moments of "arranging" their limbs, often shown in naked disharmony. The same goes for the faces, increasingly portrayed with disagreeable expressions that do not confer beauty, in the conventional sense, on the young dancers. Degas carries out a process of demeaning and materializing the female figure.

In his sublime prose, Paul Valéry brings to the surface of his memory a single great image synthesized from myriad sheets containing one, two, three, or several ballerinas. This single image holds an expression of the essence of Degas's studies: the more the artist observed the female figure, the more he was seized by the temptation to destroy the grace of the beauty that in the form of marble nudes, for centuries and centuries, had informed his idea of pure and chaste innocence. "Not women, but beings of an incomparable substance, translucent and sensitive, madly irritable glass flesh, domes of flowing silk, transparent crowns, long streamers, alive, all run through by quick waves, fringes and ripples that they fold and unfurl; and meanwhile, they spin, they bend, they take flight, as fluid as the massive fluid that compresses them, marries them, sustains them from all sides, makes room for them at the slightest contraction, and replaces them in form. There, in the inflexible fullness of the water that seems to offer no resistance at all,

these creatures have an ideal mobility, where they spread out and gather up their radiant symmetry. No flooring, nothing solid for these absolute ballerinas: no stage, but a center to lean on in all the points that give way where desired. No solids, in their figures of elastic crystal, no bones, no articulations, rigid joints, segments that can be counted…"

Degas was the first desecrator of the female figure, which painting had idealized by canceling the more carnal and terrestrial aspects of the human form; he used his art to classify, with the meticulousness of the zoologist and the elegance of the genius painter, the complex mechanical system of a human being. The obsessive aspect of the study of the figure is also linked to an erotic component, perceived by both Valéry and Vincent van Gogh. Valéry writes: "Not one human ballet dancer, ardent woman, intoxicated with movement, with the poison of her excessive strength, of the fiery presence of gazes filled with desire, no, he was never able to express the imperious offer of sex, the mimetic call of the need for prostitution, like some huge jellyfish that, with the wavy starts of her billowing skirt and festoons, which she lifts and lifts again with a strange and immodest insistence, turns into dreams of Eros."

In a less poetic way, but in more prosaic tones, laced with a dash of sarcasm, Van Gogh writes to Émile Bernard: "Why do you say that Degas's manly impulses are weak? He lives as if he were a humble notary and never thinks about women, of course; and in the self-awareness of having loved them before, and often spent time with them, one might think that, once he had fallen cerebrally sick, he should become incapacitated in painting as well. Instead, Degas's painting is virile and impersonal precisely because he has accepted to be nothing other than a humble notary who finds it distasteful to enjoy himself. Thus, he watches human animals stronger than himself get aroused and make love, and he paints them well, precisely because he does not permit himself the claim to do as much." The artist, in fact, for reasons not given by the sources,

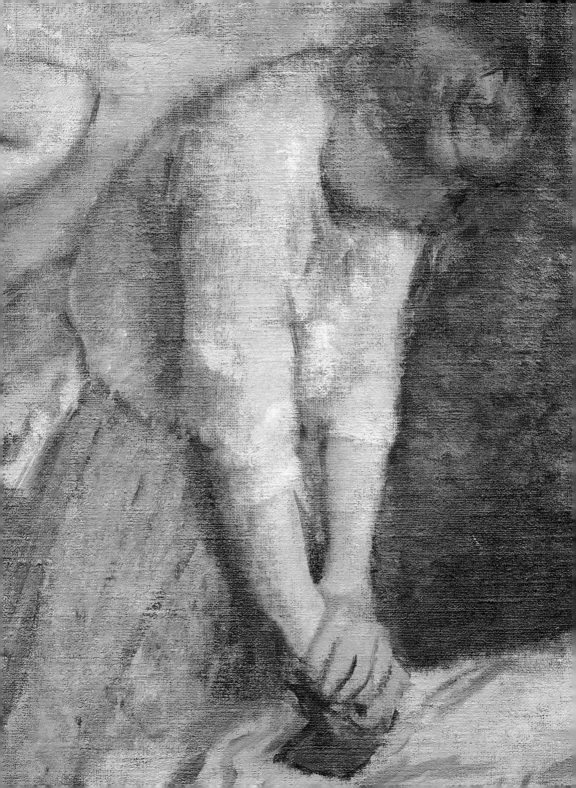

never married, never started a family, and remained faithful to his art; by the time he was old, he would complain about his loneliness, though, without ever truly regretting it.

The many observations the painter made about the postures of the human figure permitted him to renew the vision of them that had accumulated over the centuries in the minds of painters, due to convention. Degas freed himself of such compromises and opened the way to a line of research that the Nabis first took up, and later the Expressionists.

In 1937, Pierre Francastel summed up the extraordinary arc covered by Degas in the course of his experiments: "Very close to the aesthetic of the Second Empire in the first part of his career, he is quite close to us in the last." Furthermore, the art historian broaches an important question when he observes that although his modernity cannot be set in doubt, in any case, it should be considered whether this evolution was strictly personal, or if it makes up one of the facets of impressionism.

Degas had been interested in the portrait genre since the days of his training; it was, indeed, the subject that the painter took on from the outset with the greatest commitment. Thus, the series of portraits that he did in his early years has the flavor of a genuine family album. At first, he accepted the "poses" conventional in the official field of portraiture, but starting in the mid-1860s, he updated his approach according to the ideas of realist painting, representing his subjects in settings that were less and less artificial compared to earlier works. The artist remarked, "To do portraits of people in typical, familiar poses, taking care in particular to match their body language to their facial expression. Thus, if laughter characterizes a dear one, let him laugh. There are, of course, feelings that cannot be rendered, out of decency, since the portraits are not just destined to us painters. How many subtle details to interpret!" Sometimes it seems that in the portraits of the 1870s, the artist captured a casual moment of an evening spent together

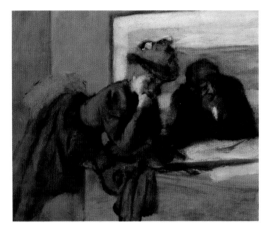

and set it on the canvas, while from his words, we can infer how carefully prepared the pose was; it was as well thought-out as any painting of the École des Beaux-Arts, although now the pose was only correct if it highlighted the presumed naturalness that the painting was to reveal.

In 1876, the critic Edmond Duranty wrote his essay "La Nouvelle Peinture – À propos du Groupe d'Artistes qui expose dans les Galeries Durand-Ruel," a fundamental text for a grasp of impressionism. In it he takes on the problem of the portrait. "And since we closely connect all nature, we will not separate the person from the backdrop of the apartment, nor from that of the street. But around him and behind him, there are furnishings, fireplaces, plastering, paintings, a wall that expresses the figure's wealth, his social class, profession […]. The language of the empty apartment must be sufficiently clear as to permit the viewer to construe the character and habits of whoever lives in it; and the street will reveal by its passersby the time of day

and the moment of public life depicted. [...] The window is another frame that accompanies us the whole time we spend at home, and this time is considerable. The square of the window, depending on whether we are near to it or far, whether we are seated or on our feet, crops the outside view in the most unexpected way [...], providing us with endless variety, the improvisation that is one of the great joys of reality." Duranty's words reflect precisely what Degas achieves when he paints portraits. When he portrays Diego Martelli, art critic, the artist places him in an apartment brimming with books and reviews that denote the writer's activity; Henri Rouart, industrialist and painter, Degas's friend since the days of the Lycée, is portrayed, instead, before his factory; Marie Dihau, famous musician, appears next to a paino.

The artist had shown his first canvases with the subject of horse races at the 1866 Salon. The horses, like the nudes, were painted in series, reproduced in many sheets in order to study carriage and movement. In 1878, Muybridge published his first photographs of the horse in motion. Degas made a few sketches in his notebooks from those photos. While the early depictions of the races are works that betray a marked interest in the amusements that the city elite indulged in at the racecourse, in the 1880s, the horse becomes the object of explicit interest, especially with respect to the possibility of representing movement. To this theme Paul Valéry dedicates a section of his essay entitled "Horse, Dance, and Photography." "The horse walks on tiptoe," Valéry affirms, "four hooves carry it. No other animal resembles a prima ballerina, the star of the corps de ballet, as much as the thoroughbred in perfect equilibrium, that the hand of the rider seems to hold suspended, as it advances by small steps in the full sunlight. [...] [Degas] was one of the first to study the various aspects of this noble beast in motion, by means of the photographs of Major Muybridge. After all, he loved and

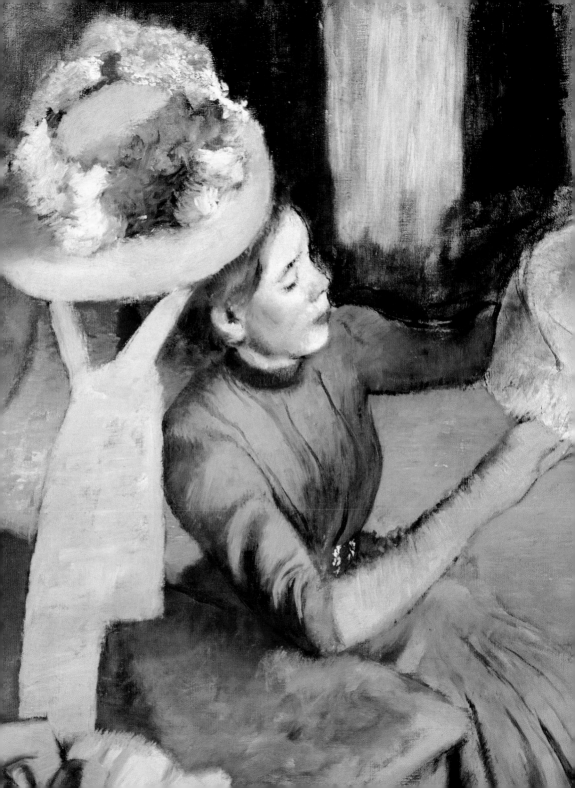

appreciated photography at a time when most artists disdained it, or dared not confess they made use of it." The snapshot gave painters the opportunity to observe and substantiate the fallacy of the painterly ideas held until then about the horse in motion. *Probable* images were attributed to those rapid movements, images that the snapshot proved to be mistaken. Degas found in the racehorse, a powerful, aristocratic animal, graceful and sleek, "nervously nude in its silky coat," as the artist defines it in a verse, a rare theme that fascinated him. The artist discovered in the horse, as earlier in the ballerina, something that came close to his own temperament: a pure being, a "classic" surviving in the reality that he can see all around him. Degas considered the horse a noble, elect subject that can unquestionably seduce an artist who is led by his very nature to make "exquisite choices," both in life and in art.

It was to do his paintings of horses that first induced the artist to use sculpture, an activity that he never abandoned, even if he did not practice it with the same continuity as painting. Degas himself admits in an interview with Thiebault-Sisson of 1897: "The older I get, the more I realize how in order to achieve an interpretation of the animal, a precision so perfect as to give a sensation of life, it is necessary to resort to the third dimension, and not just because the work of the modeling requires thorough observation on the part of the artist, a capacity for keeping attentive over a prolonged period, but because approximations are not admissible."

The artist, as Valéry points out, began to use photography early on, when most artists still refused to recognize the great potential of this device. For the equipment, the plates, and everything else that a photographer could need, Degas habitually went to Tasset et Lhote, in Paris, Rue Fontaine, where he spent entire evenings studying the enlargements of his negatives. Degas also did silver plates, which he exposed with images of female figures used for the execution of the nudes of the 1890s. From a practical point of view, in

fact, photography allowed the painter to reduce the burdensome practice of sittings with models, thus streamlining the execution of his paintings.

On April 1, 1880, the fifth Exposition de Peinture opened in Rue des Pyramides. Degas's works were reviewed by the famous critic and man of letters J. K. Huysmans, who, nine years later, in 1889, dedicated several sublime pages in his *Certains* to Degas's nudes. Huysmans, with brilliant prose, gives a voice to the undressed female figures that Degas portrayed with an unforgiving gaze as they dressed and made up. Huysmans grasps the dual role of the pastels used by Degas: on the one hand, there is a relentless eye that bares the wretchedness of the human body, and on the other, the elegant touch of an artist of genius who glorifies the wretchedness of the flesh with the beauty of interpretation. "Degas, who in splendid pictures of dancers had already so implacably rendered the decadence of the mercenary stupidity of mechanical clowning and monotonous leaps, cultivated […] with his studies of nudes, a meticulous cruelty, a patient hatred. It seemed as if he sought his revenge, tossing the most excessive outrage in the face of his century by demolishing that ever-spared idol, woman, whom he degrades. And all the better to recapitulate his repugnance, he picked them fat, pot-bellied, and short. Here is a red-haired one, big and fat, stuffed, who arches her back, making her sacrum poke out against the stretched roundness of her backside; she bends over, trying to lift her arm behind her shoulder to squeeze the sponge that drips on her spine and ripples at the small of her back; there, a blond, contracted, squat, and stiff, who all the same turns her back to us; that other one has finished her cleaning chores, and placing her hands on her back, she stretches in a somewhat mannish manner, as if warming herself before a fireplace, lifting the vents of her jacket; yet another is a large woman crouching, leaning way over to one side, lifting one leg, passing

55

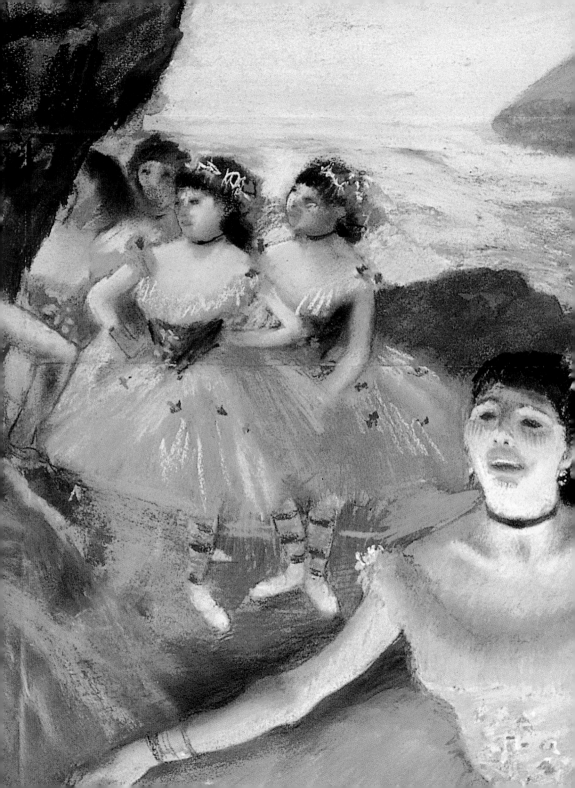

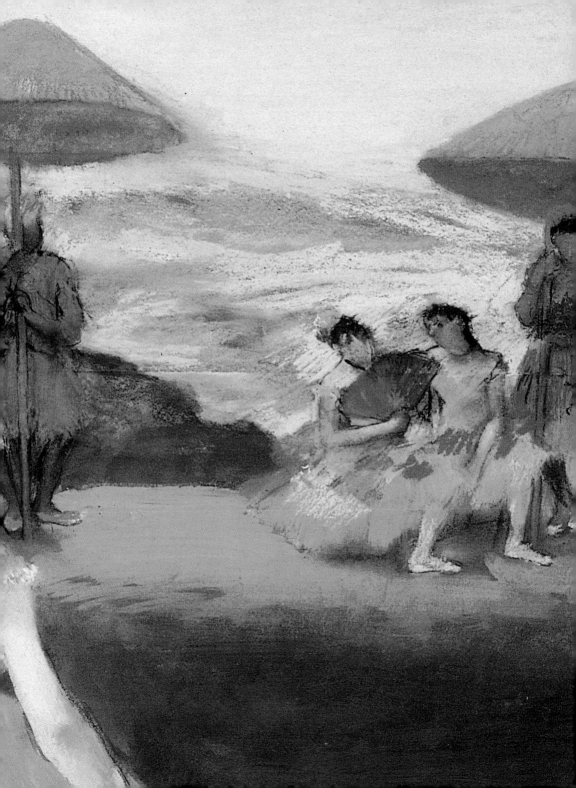

her arm under it, washing herself in the galvanized bath tub; a last one, this time seen frontally, drying her chest. [...] These are, briefly described, the unkind poses that this iconoclast attributes to the creature worshiped by so many useless gallantries. There is, in these pastels, something of the cripple's stump, the withered breast, the swaying of a man without legs, or thighs, a series of poses inherent to women, even young and lovely women, adorable if reclining or on their feet, but froglike or monkeyish when, like that other, they must crouch to conceal their wretchedness under such treatment. [...] But apart from this particular accent of disdain and aversion, we must see in those works the unforgettable authenticity of the models, executed with a sweeping and far-reaching hand [...]; we must see the color, bright or muted, the mysterious, opulent tone of those scenes; it is the supreme beauty of the flesh made bluish or pinkish by the water, brightened by closed windows with muslin curtains, in dim rooms where one can see, in the diffused light of courtyards, walls hung with Jouy fabric, sinks and basins, phials and combs, polished boxwood brushes, pink copper footwarmers!"

Degas was also a keen observer of the city life that he portrayed in several canvases inspired by the sparkling fin-de-siècle Parisian life.

The philosopher Pierre-Joseph Proudhon, in his writing of 1863 *Du principe de l'art et de sa destination social*, stated that there must necessarily be a relationship between art and conscience. Proudhon meant to encourage artists to select their alternatives in the world with care and sincerity, since "art quickly deteriorates when it ceases actively to involve awareness, when it becomes indifferent, when it is no more than an object of truth and luxury." This relationship between art and awareness can only happen through art's abandonment of the imagination, that is, the abandonment of subjects taken from contexts different with respect to the time in which the artist lives.

Degas photographed in Boulevard
de Clichy, Paris, during the last
years of his life

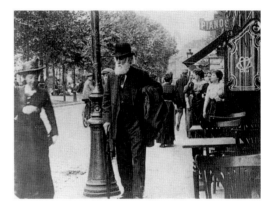

"Art, a product and a stimulus of the mind,
comes to be with humans and with society.
From the very outset, it proves to be not a
product of the imagination, but a serious
subject, like an essential demonstration of life,
a condition of life. It enters into reality, into the
private realms of life. Art embraces humanity
as a cloak of glory; it is her destiny, her purpose.
All our life, the words, the deeds, even the
simplest ones, […] everything that we do, every-
thing that we are, call to art and ask to be
revealed. Art saves us from vulgarity, from
banality, from roughness, triviality, from indig-
nity; it civilizes, urbanizes, educates, ennobles."

It seems that what Degas did with reality
agreed with the ideas of this important expo-
nent of French culture. To look to the world
that is familiar to us, to what we see when we
go out of our house, moving around the city;
to try to be fully aware of, to interpret what
is before us; to lift the veil of obtuseness and
observe critically: all this is the purpose of art.
Degas was a keen observer, endowed with a
great spirit of mimicry. About this aspect of

The Tub
(detail), 1886
Paris, Musée d'Orsay

the artist's personality, Valéry's testimony is illuminating: he tells how Degas, alone and irritable, not knowing what to do in the evening, wandered through the city in search of situations to observe. He would come to a streetcar or omnibus stop and board the vehicle. From there he would ride all the way to the end of the line, and once there, all the way back home. One day, Degas told Valéry about something he had observed on a streetcar. "He told me, then, that a woman sat down not far from him, and he noticed her concern about being seated well and well put-together. She ran her hands over her dress, smoothing it [...]; she pulled her gloves stretched well over her hands, buttoning them carefully; she ran her tongue over her lips, nibbling them slightly; she arranged her dress to freshen up her underclothes. Finally, she spread her hat veil, and after lightly pinching the tip of her nose with a quick gesture she pushed a curl in place and, not without having checked with a glance the contents of her purse, she seemed to finish this series of oper-

ations by taking on the pose of someone who has completed her job, who, having done all the humanly possible before undertaking a task, has her soul easy and puts herself in the hands of God." Degas, telling all this, repeated the pantomime, and taken up by his tale, and with a somewhat misogynist air—muses Valéry—reproduced with great transport what could have been the subject of a painting.

From this spirit of observation come those paintings that have bits of everyday life as their subject, as in *Women in a Café* or *The Glass of Absinthe*. It does not matter that for *The Glass of Absinthe* Degas had two friends pose, a painter and an actress, because what he depicted was born of one or many episodes that the artist had observed and then recreated and unified in the single moment of the painting. The procedure of setting up the scene is not very different from the method used for staging and constructing historical paintings. The theoreticians of realism, in fact, did not object to history painting, as long as the history represented was of a contemporary

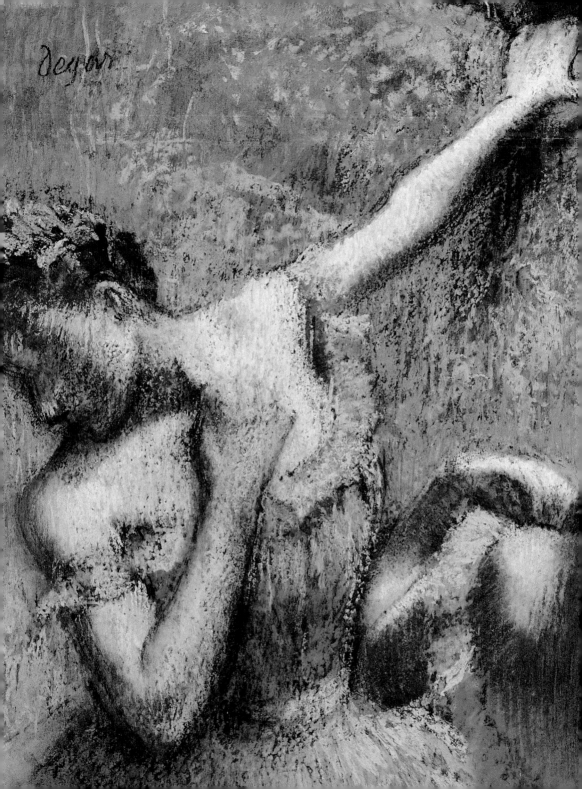

subject. Instead, another question arises: does the idea of history undergo a fundamental change when the contemporary "history" to which realists allude is not that of great events, commanders, heroes, emperors, but rather the history of "small events," the history of men and women, and no longer just of exceptional cases. This, exactly, is the idea of history that the novel had instilled in people's minds, electing the common man as the new hero within the more complex social structure that had formed as a result of the industrialization that characterized the nineteenth century.

From the 1870s, Degas painted pictures with washerwomen, which he proposed in many versions in the following years. In the context of French painting, subjects of this kind had been treated in around mid-century by Millet, Daumier, and Courbet. The interest that Millet had, in around 1850, for country life with its workers shifted, by about 1860, with Daumier, to the hard work that was done on the banks of the

Seine, where the tireless washerwomen are depicted in their shabby clothes. Compared to the merry washerwomen portrayed in the eighteenth century by Fragonard, Boucher, and Hubert Robert, Daumier's bore a message of sadness and sorrow kept in check by the dignified resignation to their lot. In Degas's washerwomen, the ideological consideration gives way to an attitude of curiosity and irony that leaves no room for social protest; indeed, it comes naturally to whomever sees Degas's lower-class women to wonder if he had ever had occasion to consider the same reality captured by Daumier just ten years earlier. In any case, his attitude probably did not stem from a meager political sensibility, but from the conviction that art and reason of State should not contaminate one another. Valéry also discusses Degas and politics: "Degas, the man most scornful of the right to vote in the world, the most ignorant of business, the most indifferent to the enticements of lucre, judged power as if the real conditions of power had ever allowed exercising it in complete integrity,

in grand style. […] Thus, Degas could imagine an ideal man of state, passionately pure, who observed, in his activity, with respect to people and their circumstances, the same unyielding will, the same rigor of principles that he himself observed in his own art."

At the start of the 1890s, Degas moved house and occupied his new apartment on three floors in Rue Victor-Massé. As he confessed in his letters, he had a particular fixation for the furnishings, even if after all he had often lived in a context dominated by great sobriety. Every now and then he had even considered the possibility of donating everything to the state, to make his home an artist's museum, but then he always gave up because he had seen a few in Paris that had revolted him.

In these years he grew kinder toward his dearest friends, admitting that in the past he had not been easy to get along with. For example, he wrote a letter to the painter Évariste Bernard Valernes saying, "I must beg your pardon for something that turns up often in your conversations and even more often in your thoughts: that of my having been, in the course of our longstanding artistic relationship, *hard* on you. […] I was especially hard on myself, too; you must remember it well, since you reproached me for it and were amazed at my own scant faith in myself. […] I was and I seemed hard on everyone because of a sort of brutish impulse that arose from my doubts and my ill humor. I felt so awkward and poorly equipped, so feeble, while my artistic *calculations* seemed to me to be correct. I was bad-tempered with everyone, even myself. I must beg your pardon if, on the pretext of this cursed art, I hurt your intelligent and lofty spirit, perhaps even your heart."

During his mature years, a slow but relentless psychological decline set in for the artist, leading him to contemplate the themes of old age, disenchantment, and death: "To be unmarried and approaching fifty years of age brings on some of these moments in which a sort of door closes, and not just for friends. All around

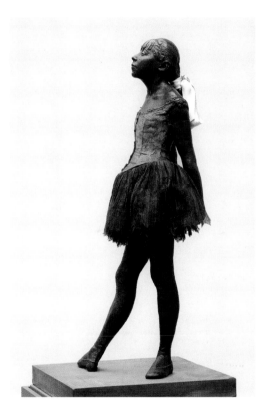

you everything goes out; and just once, you cancel yourself out, you kill yourself in disgust. I made so many plans, but here I am, blocked, impotent; and then I lost my train of thought. I always thought I had time; what I didn't do, what I was barred from doing in the midst of all my bothers, I never lost hope about getting back to it one fine day, in spite of my failing eyes. I accumulated all my plans in a closet, the key to which I always carried with me: now I've lost that key…"

The eye problems that had plagued him since his youth worsened toward the end of the century, and soon brought him to near-blindness. This grave impairment plunged the painter into a decline that caused him to retreat into absolute isolation. Finding himself unable to continue with his work, Degas gradually lost interest in the world outside, which he could hardly see any longer. At first, he dedicated himself primarily to sculpture, and his last pastels show a simplifying of the forms that must have been caused

by this disastrous difficulty. Subsequently, the loss of sight caused him to become indifferent to life. Valéry describes the artist's twilight, saying that his hands still sought forms when his eyes could no longer. He handled objects, since it was now the sense of touch that was dominant in him. He often used tactile adjectives to describe things. "The eyes, which had worked so much, were lost, the mind absent, or despairing; obsessions and repetitions proliferating; terrible silences that conclude with a dreadful realization: 'All I think about is death, there is nothing sadder than the deterioration of such a noble existence as a result of old age.'" It comes naturally to think that this isolation in his old age was simply an accentuation in later years of an innate personality trait, of his predisposition to "stand aloof, not to trust people, to denigrate them, to cut them down, to label them horribly. Perhaps the misanthropy holds a seed of senility, since it is *a priori* a predisposition to melancholy and always the same approach to the variety of individuals…"

Stricken by a cerebral aneurysm, Edgar Degas died on September 27, 1917. Europe was torn by the war, while one hundred persons accompanied his corpse to the cemetery in Montmartre, where he was buried in the family tomb.

One year after the artist's death, his collection of antique and modern paintings was auctioned off. This was followed by five sales of his studio works, all organized by the Georges Petit gallery. In 1924, the same gallery organized an exhibition of the painter's works. In the 1930s, a few retrospective shows of the artist were mounted in Paris and in the United States. During the same years, Paul Valéry's writing on him was published, consecrating the physiognomy of the artist's genius and intentionally isolating his figure from that of the impressionist group. Valéry never speaks of Degas's painting in terms of impressionism. At the same time, analyzing the artist's profile, Francastel wonders whether his indisputable modernity should be considered an integral part, or not, of impressionist painting.

In the 1940s, John Rewald's text, *The History of Impressionism*, places the figure of the painter squarely inside the movement represented by the exhibition at Nadar's in 1874. In any case, notwithstanding the marked individuality critics have acknowledged in Degas's painting, Valéry's interpretation of the artist indubitably remains essential to our understanding of him; it is an evaluation that is still valid today, in its historical perspective as well, as it was formulated in years in which it was already possible to see the fertile legacy that Degas left to the future generations of artists. The opinions expressed by more recent critics are lucid and knowledgeable; they see in Degas's work the conditions necessary for the developments shown in the painting of the Nabis (especially Bonnard) and the symbolists (with particular reference to Redon's explorations), as well as an influence in the birth of the highly unnatural and complex vision of the human figure that Picasso formulated in the early years of the cubist experiments, starting with *Les Demoiselles d'Avignon*, painted in 1907.

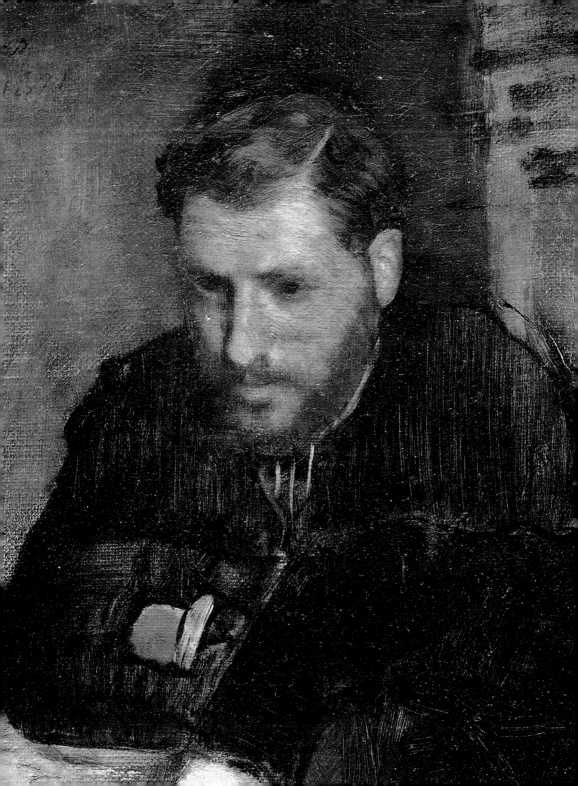

The Masterpieces

Self-portrait

1854–1855
Oil on canvas, 81 × 64.5 cm
Paris, Musée d'Orsay

The series of portraits that the young Degas did of his family and friends (of which *Self-portrait* is one) has the flavor of a genuine family album. The painter accepted all the poses favored by official portraiture, which at the time was headed up by Jean-August-Dominique Ingres. Degas greatly admired Ingres, and at one point pleaded with a family friend, the collector Édouard Valpinçon, to let him copy the famous *Bather* by the master of Montauban, which Valpinçon owned.

In the portraits he did in this period, an elegant line defines his forms, and the tonal shading is realized through the juxtaposition of areas of color in light and areas of color in shadow. Degas's espousal of Ingres's purism can be seen in particular in his *Portrait of Hilaire de Gas*, his grandfather, and in the famous painting *The Bellelli Family*.

In the painting shown here, began when the painter was twenty years old, Degas portrays himself as a stiff and formal young man of the upper ranks of society; on his face, one can perceive an air of youthful candor that no longer appears in the later *Self-portrait*, where the painter depicts himself as a self-possessed Parisian dandy, with hat and gloves in hand.

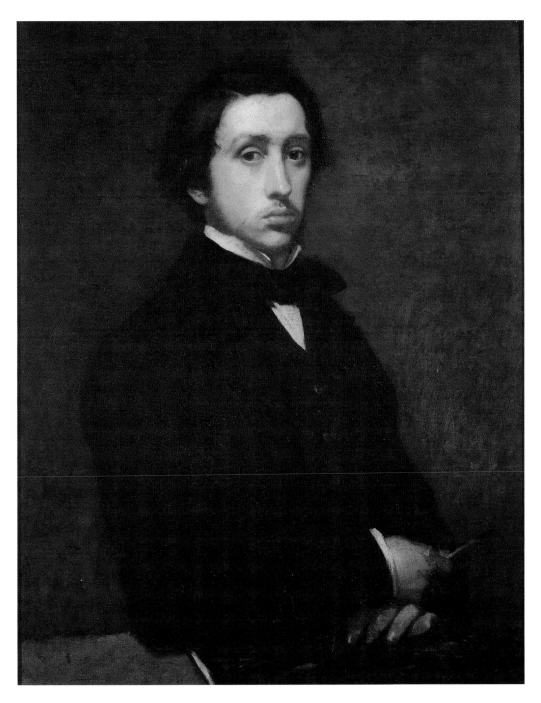

The Bellelli Family

1858–1867
Oil on canvas, 200 × 250 cm
Paris, Musée d'Orsay

Just after Degas's death in 1917, the Louvre purchased this painting, which today is housed at the Musée d'Orsay in Paris. Ever since its purchase by the French state, *The Bellelli Family* has been considered one of the masterpieces of the painter's early career. There are several uncertainties about the making of this painting. We know for sure that Degas began studying the composition of the work during his stay in Italy, in 1858–1859. In his correspondence with his father, there are explicit references to a work that he had started that had for its subject a few members of the Bellelli family, in whose home in Florence Degas was a guest. At the end of December 1858, Degas's father answered his son: "You started such a large painting on December 29, and you believe you have finished it on February 28. We highly doubt it: in short, if I have any advice to give you, it is to do it calmly and patiently, because otherwise you risk not finishing it and to provide your uncle Bellelli with a good reason for being disappointed." We cannot say if the canvas to which Degas's father was referring is the Orsay painting, or a rough copy of the definitive one. In any case, back in Paris, Degas continued to work on the painting for all of 1859: he did drawings, sketches and "studies of effects of values and decorative colors," as he called them, which were a great challenge to him, and made him confess to a friend that, perhaps, the profession of artist was too demanding for him. He took up the painting again in 1860, on the occasion of a second trip to Florence (during which Degas studied his uncle Gennaro's physiognomy), and probably finished it in 1867.

The picture shows Degas's aunt and uncle Bellelli with their two daughters. On the left are Degas's aunt and the young Giovanna Bellelli; at the center, Giulia Bellelli is seated and turns her distracted gaze toward her father, shown in profile on the right.

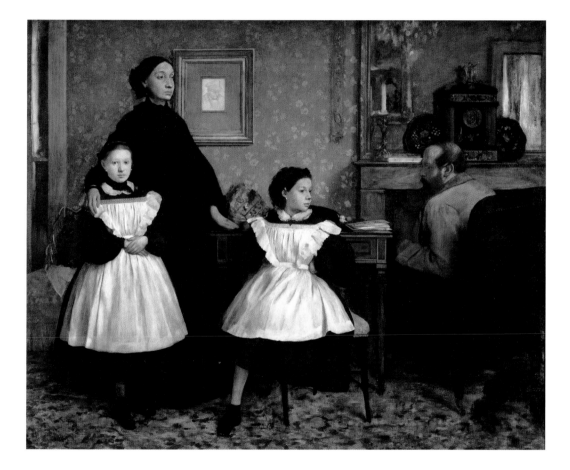

Young Spartans

1860–1862
Oil on canvas, 109 × 154.5 cm
London, National Gallery

Between 1859 and 1865, Degas did important history paintings. In 1859, he had returned to Paris after his travels in Italy, and weary of studying modern painting, the artist dedicated himself to the realization of history pictures. His first teachers had no doubt pointed him toward this genre of painting: they were Barrias and Louis Lamothe, a pupil of Flandrin's, who may have passed on to him the formalist sensibility that is apparent in the painter's early work.

At the start of the 1860s, Degas took on a classical subject: the education of young Spartans. The subject, executed with extreme sobriety in terms of both form and color, is not at all lacking in instructive significance, and is still in keeping with an idea of painting addressed to moral teaching through illustrious examples from the past. The picture depicts Spartan women inciting the young men to fight, and in the background, the mothers of the combatants look on at the challenge. The composition is based on a rigid symmetry that recalls, even in the stiff poses of the figures, the rigor of neoclassical painting. The nudes, however, are treated in a naturalistic way, and the faces are not the fruit of the repetition of a single physiognomic type, but portraits done of models, each of which is defined by a different expression. The color, applied in large zones, renders homage to the frescos of the pre-Renaissance Italian painters, as well as to the painting of Ingres. *The Apotheosis of Homer*, which Ingres painted in 1827, was one of the young Degas's favorite paintings. "One day," recalled Paul Valéry, "Henri Rouart dared to criticize the coldness of *The Apotheosis of Homer*, observing that all those frozen in their noble poses exhaled an icy atmosphere. 'What!' exclaimed Degas, 'But it's so beautiful! … An empyreal atmosphere fills the canvas.'" Valéry concludes ironically, "He was forgetting that the empyrean is a fiery region."

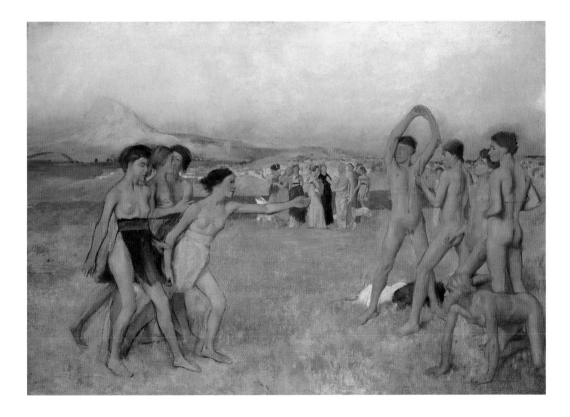

Semiramis Founding Babylon

1860–1862
Oil on canvas, 151 × 258 cm
Paris, Musée d'Orsay

The painting depicts the biblical episode in which the queen Semiramis, on a terrace with her retinue, oversees the progress of the building of the city of Babylon, which she founded on the banks of the Euphrates River.

The subject, which Degas made austerely, explicitly rejecting polychromy, can claim as sources of inspiration Giacchino Rossini's *Semiramide*, staged at the Paris Opéra in 1860, Voltaire's play of the same name, performed in Paris in 1855, and the important archaeological discoveries brought to Paris with Napoleon's campaigns. In fact, the figure of the horse has been recognized as a citation of a fragment of the Parthenon frieze. From a formal point of view, the work takes some inspiration from the synthetic constructions of such Italian Renaissance masters as Piero della Francesca, Masaccio, and Luca Signorelli.

When the picture was unveiled, it aroused negative opinions. The only critic to praise it was André Michel, who wrote: "There is not a single piece, a single element of the picture [...], that does not impose itself on the spirit with a slow and persuasive authority." Although it belongs to the genre of history paintings that was highly fashionable in Second Empire France, the fact that the painting was not appreciated suggests that the painter treated his subject with an originality that most did not understand. He did not conform to the opulent taste in vogue among the students of the École des Beaux-Arts, preferring a simplicity that transcended the historical moment represented and seemed to anticipate the quiet grandeur that Puvis de Chavannes was to achieve in the following two decades. This work brings to mind the masters studied in his youth and elected as models in this still experimental phase. The landscape, left unfinished, and the countryside, rendered in broad chromatic swathes, for example, may have been suggested by the memory of Masaccio's frescos in the Brancacci chapel.

Portrait of the Painter Bonnat

c. 1863
Oil on canvas, 43 × 36 cm
Bayonne, Musée Bonnat

Léon Bonnat and Degas had been friendly since their student days. Later on, they took different directions in painting. In Bonnat we find one of the best examples of the Third Republic style of portraiture. Compared with Degas, who tended to seek naturalness in the poses chosen for his portraits, Bonnat preferred hieratic positions and a style striving for a nearly photographic representation of the subject. Bonnat's formula, which melded a realist precision with an idealized presentation of the subject, met with great popularity in the realm of official portraiture for high-ranking political figures.

In the memoirs of Ernest Rouart, the son of the painter Henri Rouart, there is an episode that is borderline between the anecdotal and testimony, and reveals the rather harsh side of Degas's temperament which he often showed to his friends and acquaintances. Rouart recounts: "The way that [Degas] met up with Bonnat, of whom he had lost sight for some time, is quite amusing. At the top of the omnibus going to Cauterets to take the spa waters, he found himself sitting next to a man who identified himself. It was Bonnat, who said to him, 'So, Degas, whatever became of that portrait you once did of me? I'd very much like to have it…' And Degas: 'It has always been in my studio, I would be glad to give it to you.' After a moment's hesitation, Bonnat ventured: 'But you don't like anything I do!' (Of course, he must have been thinking about proposing something in exchange.) Very irritated, Degas replied, 'What do you want, Bonnat, we each went our own way.' And the thing ended there. But Degas did not spontaneously keep his word. At Bonnat's request, my father had to claim the portrait, and with some insistence. One day, Degas decided to take it to him in Rue de Lisbonne. He even wanted my father to keep the portrait for himself. Naturally, my father did nothing of the sort."

A Woman Seated Beside a Vase of Flowers (Madame Paul Valpinçon?)

1865
Oil on canvas, 74 × 93 cm
New York, The Metropolitan
Museum of Art

"*A Woman Seated Beside a Vase of Flowers* is the result of a technique of decentralized composition, similar to some photographs." With these words, the Austrian philosopher Karl Popper described Degas's innovative compositional approach here of placing the still life at the center of the painting and shifting the main subject, Baroness Valpinçon, the wife of the famous French collector, to one side. This decision must have been the fruit of lengthy thought on the part of the artist, who, used to contemplating the work of the great masters, was never satisfied with his own, returning to them again and again obsessively. We read in Rouart's memoirs that the owners of Degas's paintings who were aware of this mania used to take them off their walls and hide them when he came to visit, so they would not have to hear him asking to have them back for a touch-up or modification.

The composition of chrysanthemums is rendered in the smallest detail with a patient practice of infinite touching up. Degas claimed that laborious painting had its "amusing" side for the artist. A writing of Valéry's is important for understanding the artist's attitude: "One day at the Louvre, I was walking with Degas through the Grand Galerie. We stopped before a remarkable canvas by Rousseau that splendidly showed an avenue lined with oak trees. After a few minutes of admiration, I noticed with what endless attention and patience the painter [...] had seen to the details and produced an adequate illusion of the details, to the point of making one think of an endless task. 'It's magnificent,' I said, 'but what a nuisance to do all those leaves... It must be quite boring...'. 'Hold your tongue,' Degas said to me, 'if it weren't boring, it wouldn't be any fun.'"

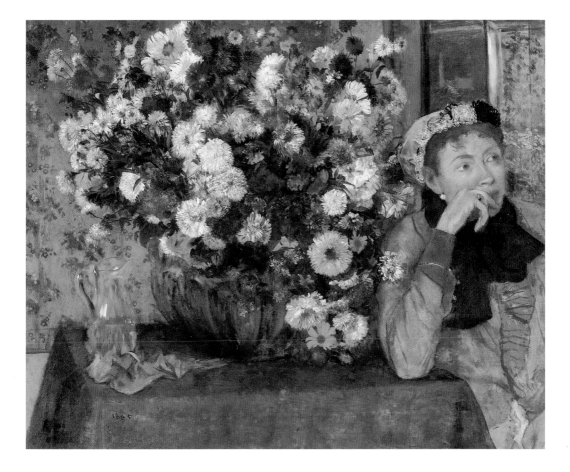

James Tissot

c. 1867–1868
Oil on canvas, 151.5 × 112 cm
New York, The Metropolitan
Museum of Art

The painter James Tissot, a friend of Degas's since youth, was to become famous for his elegant portraits of sophisticated high society ladies. Tissot and Degas shared an interest in the elegant spheres that they frequented thanks to their social background. Comparing the fame of Degas's name with that of Tissot today, we will be surprised to realize that, actually, at the time, the latter was considered an excellent artist, perfectly able to gratify the taste of the cultivated bourgeoisie. Degas held him in high esteem, and, on the occasion of the first impressionist exhibition in 1874, sought to persuade him to join the group. Tissot certainly cannot be considered an impressionist, but according to Degas, he had every reason for appearing in the show, as he too had dedicated his painting to subjects taken from contemporary life. In a letter written in the spring of 1874, we read: "Come on, dear Tissot, no hesitation or escapes: you must show at the boulevard. It would be so helpful both to us and to you."

The portrait of James Tissot, painted in *c.* 1867, preceded Degas's friend's move to London as well as his decision not to show with the impressionist group. The thirty-year-old painter is portrayed in a domestic setting (perhaps his studio), where he sits, resting an elbow on a table, and planting his stick on the floor. The sober clothing, suited to an authentic Parisian dandy, fits in perfectly with the domestic setting around him. On the walls are hung paintings that reflect the sophisticated, cultivated tastes of the artist; on the wall behind him is a very fine Lucas Cranach and a large, orientalizing canvas (today at the Louvre) which reminds us of the broad circulation that Japanese prints enjoyed beginning in the 1860s in Paris. An unfinished painting sits on the easel to the right, while two other canvases rest on the floor.

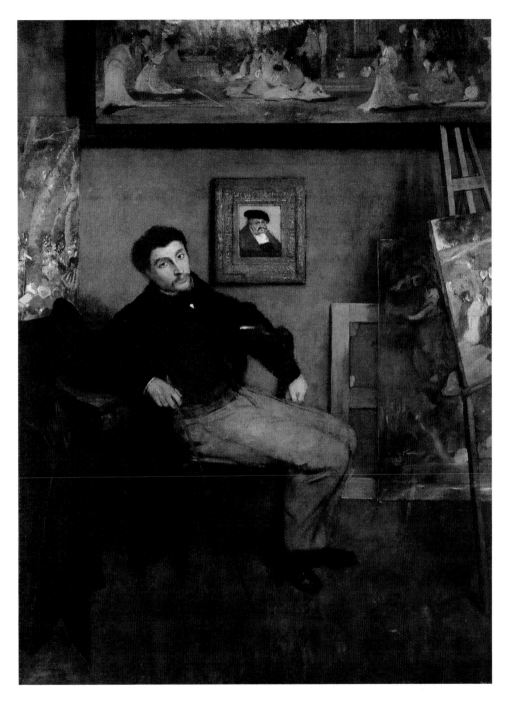

The Parade
(Race Horses in front of the Tribunes)

1866–1868
Oil on canvas, 46 × 81 cm
Paris, Musée d'Orsay

In 1845, Baudelaire, poet and art critic, proposed to painters that they depict the "heroes of the present times" in their distinct black suits. He meant to encourage artists to leave behind the genres of the great painting of the Salon (history and mythology) and concentrate on subjects offered by modern-day life. Baudelaire's idea was like a dazzling revelation for Manet, and later it was adopted by the future impressionists, Degas first among all. Contemporary life, as the poet intended it, had never been raised to the level of a great painting subject. In the past, especially in the seventeenth and eighteenth centuries, pictures connected with everyday life had been relegated to the lesser category of "genre paintings." Therefore, in order to approach contemporary themes, the impressionists had to invent a new language, and Degas was, among the group's painters, perhaps the one who explored contemporary life with the greatest interest.

The custom of going to the horse races, like that of taking swims in the sea or walks in the public parks, was a fashion created during the Second Empire. Degas masterfully renders the atmosphere at the races in his work *The Parade*. The painting shows the elegant spectators crowding the stands, the track where the race is held, the smoking chimneystacks in the background suggesting the dawning industrialization of the capital. The nervous horses paw the ground as they are made to parade before the public, and the sudden balk of one of them in the distance captures the tense climate of expectation that precedes the contest.

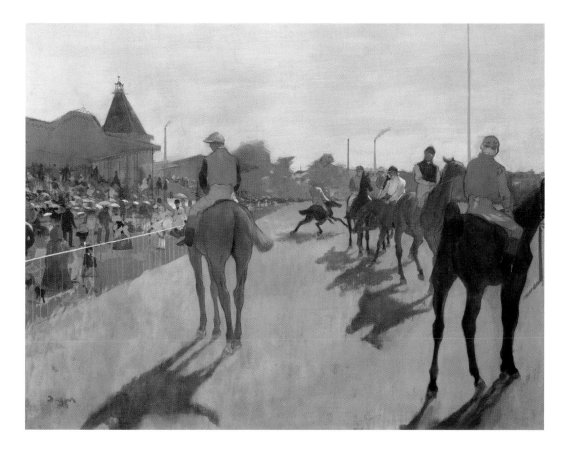

Portrait of a Young Woman

1867
Oil on canvas, 27 × 22 cm
Paris, Musée d'Orsay

The dating of this portrait is rather controversial. Some scholars put it as early as 1862, while others push it as far back as 1870. The small size and the metaphysical beauty of the work prompted the critic Georges Rivière to write: "This portrait has a wonderful design, it is as beautiful as the most beautiful of Clouet's, the greatest of the Renaissance portraitists." In effect, in support of the early dating, there is an almost otherworldly feeling that dominates the history pictures and the youthful portraits. The face of the aunt Bellelli in the famous portrait of the family seems a natural counterpoint to this "classical" head of a young woman.

The woman, who seems absorbed in thoughts that make her immune to any contact with the world, directs her gaze to something or someone outside of the picture. The hieratic quality of the faces typical of sacred paintings that Degas had studied during his years of training has been transferred to an intimate subject like this little portrait in the Musée d'Orsay. Already receptive to the call of realism, but still keeping close links with his youthful studies of the early masters, in the works of this period, the artist proposes the two elements in an admirable blend.

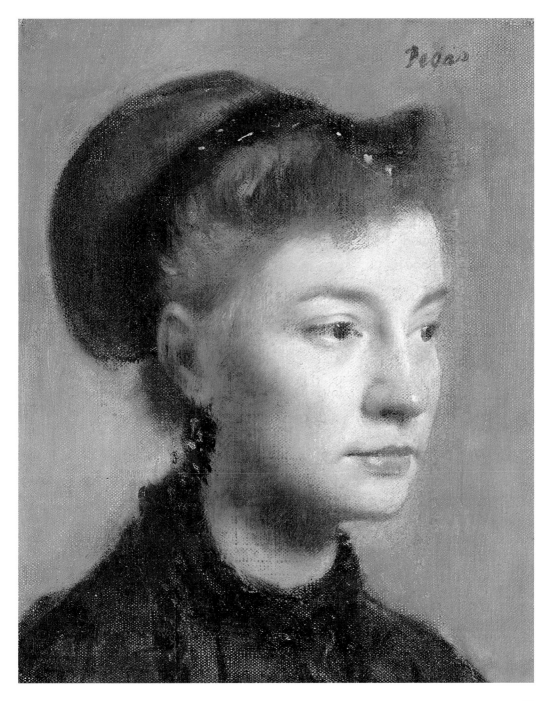

Portrait of Mademoiselle E. F... in the Ballet "La Source"

1867–1868
Oil on canvas, 130 × 145 cm
New York, Brooklyn Museum
of Art

This is the first of the artist's works to have as its subject a contemporary ballet, entitled "La Source," and performed by the famous ballet dancer Eugénie Fiocre in Paris in 1866. Degas started working on the painting in the summer of 1867, and intended to show it at the Salon of the following year.

When the artist shifted his focus from history painting to episodes from contemporary life, it was natural that theatrical subjects should attract him, since on the stage, the two genres, history and contemporary life, could meet thanks to the scenic pretense. Thanks to this compromise, Degas organizes his painting in an ambiguous way; it can be defined neither as a portrait in the conventional sense, nor a stage scene, since no element contributes to defining the stage. The painting was stylistically influenced by the understated interpretation of the sensual exoticism of Gustave Moreau, Degas's friend and confidant during his years of training, who went on to become a leading figure of French symbolism. Other important influences in Degas's personal interpretation of the exoticism emergent in French Salon painting were the painters Eugène Delacroix and Eugène Fromentin, whom he admired in these years, and among the past masters, Poussin, whose sweeping and synthetic style offered the artist a key for imbuing a theatrical scene with a mythical aura, without, however, betraying the aim to abandon the historical genre.

The composition is set near a spring, where three girls refresh themselves. To the right of the seated women in red, a horse drinks water. The artist does an excellent job in rendering the reflections of the women and the horse in the water. The rocks are barely described in the small space allowed for the background, and thanks to the use of subtle earth tones, they blend in perfectly, without overwhelming the scene.

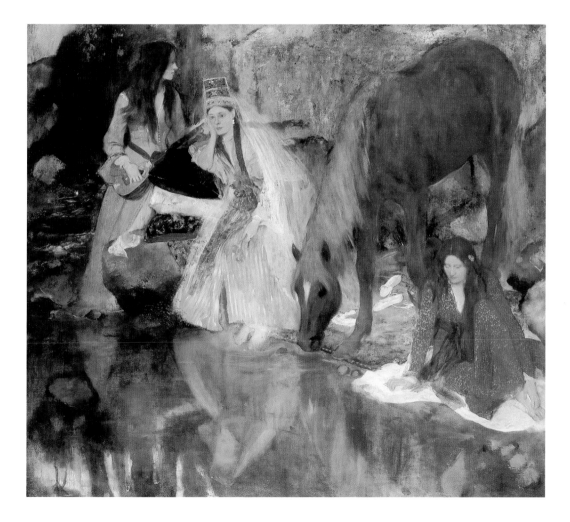

The Orchestra at the Opéra

c. 1868
Oil on canvas, 56.5 × 46 cm
Paris, Musée d'Orsay

When Degas decided to make a portrait of his friend Désiré Dihau, he made up his mind to portray the musician while he was performing with the Opéra orchestra. The painting is conceived as a collective portrait that allows a glimpse, in the background, of the ballet. The painter chose a framing that was well-designed for the effective rendering of the three perspective planes in sequence that make up the space of the painting. The foreground is occupied by the foreshortened image of the balustrade delimiting the orchestra from the theater. Moving back, the next plane holds the group of musicians, serious and concentrated in their performance. Finally, there are the ballerinas, whose heads have been cut out of the picture to make explicit the strict consequential logic involved in reading the picture. In the lower half of the painting the hues are gloomy (blacks, whites, and browns), but the note of color provided by the ballerinas' costumes is skillfully added to bring the flavor of the painting back to the elegant spirit that the subject requires.

Degas had been mediating at length on how to compose the portrait (of a single individual or a group of individuals), ever since his youthful years, and before a portrait by Van Dyck that he saw in Genoa, he wrote, "No one has ever managed to render the grace and refinement of the woman, the elegance and gallantry of the man, or the diversity of both as Van Dyck has. In this great genius there is more than one natural tendency […]. I think he reflected at length on a subject, that he steeped himself in it, like a poet."

The Orchestra at the Opéra is the first work in which Degas painted a ballet. In fact, it was within the context of the various versions of orchestras that he did between 1868 and 1876 that the subject of dance, so important in his later work, found its first illustration.

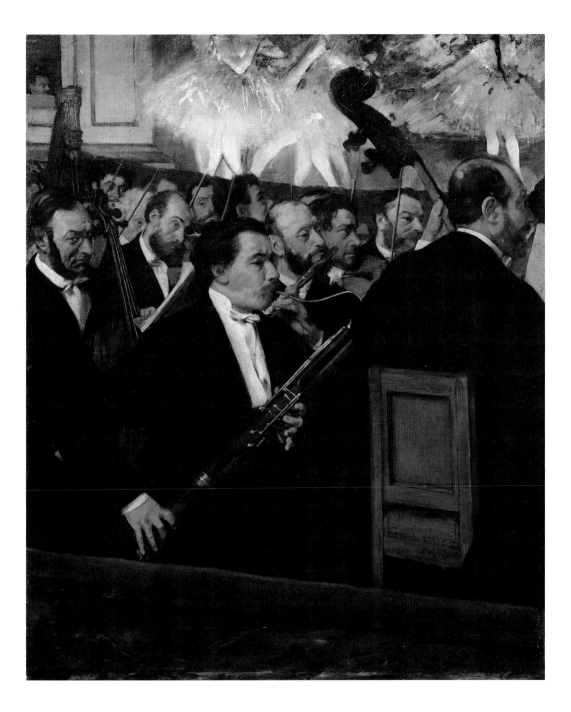

Édouard Manet and His Wife

1868–1869
Oil on canvas, 65 × 71 cm
Kitakyushu (Japan), Municipal
Museum of Art

This painting was the cause of a serious disagreement between Degas and Manet. The latter not only showed his contempt for the painting and refused the gift that his colleague wished to make him of it, but he even destroyed it in part. Degas had the missing part repaired to restore the painting, the concept of which Manet, himself, later copied, when he made the portrait of his wife at the piano. The episode clearly illustrates the difficulty the two artists had in maintaining their friendship because of their temperaments. This did not bar the great esteem they held for each other. Within the impressionist group, they were the artists most interested in figure painting. Both tirelessly studied the great masters of modern painting. Their training ground was the Louvre, unlike the others who worked exclusively *en plein air*, considering nature the sole great example to follow. The creative process of Degas and Manet was, in some respects, more sophisticated: they worked *sur le motif* through drawing, which they then transcribed into painting, always keeping in mind the example of the masters studied in the museums.

From the recollections of the painter Berthe Morisot, set down by Valéry, we learn that "Degas said that the study of nature was meaningless, since painting was an art of conventions, and that it was much better to learn to draw from Holbein; that Édouard himself [Manet], though he claimed to copy nature slavishly, was the most mannered painter in the world, and he never made a single brushstroke without thinking of the masters.

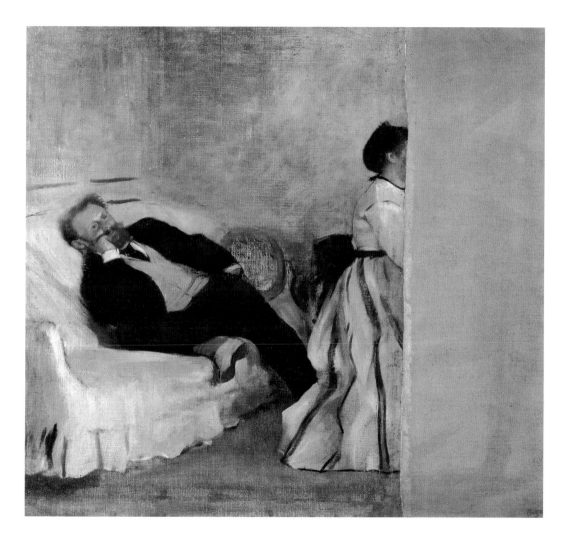

Houses by the Seaside

1869
Pastel, 31.4 × 46.5 cm
Paris, Musée du Louvre,
Cabinet des Dessins

Starting in 1868, Degas painted a series of landscapes that remain a rare event in his output. Nature is taken as a source of inspiration. Some scholars have correctly observed that Degas's landscapes seem to emerge from memory or from the imagination. In fact, they are born from the painter's memory; he did not paint them directly from life, but did them in his studio, bringing to the surface of his memory what his eye had recorded. Concerning the use of recollection in the context of artistic execution, Degas usually recounted the story of his first meeting with Ingres, an artist whom he had admired greatly in his youth. The latter, having heard that the young man before him intended to be an artist, counseled him to study nature and the masters, to then draw everything that he had assimilated in his memory again, without the model before him. We do not know if the incident, related by Valéry, actually occurred. However, the fact that Degas insisted on the mnemonic aspect of Ingres's teaching demonstrates the importance that he attached to this faculty. A draftsman of his genius necessarily had a great visual memory, which allowed him to abstract a drawing from observable reality.

The pastel *Houses by the Seaside* was done in the summer of 1869, when the painter was at Étretat and Viller-sur-Mer, and often went to pay visits to Manet, who was staying at Boulogne.

Lorenzo Pagans and Auguste de Gas

c. 1869
Oil on canvas, 54.5 × 40 cm
Paris, Musée d'Orsay

Laurent-Pierre-Auguste de Gas, the artist's father, directed a branch of his father's bank in Paris and came from an aristocratic Breton family that had moved to Naples during the French Revolution, and thence to Paris. When Degas decided to dedicate himself to painting and abandon his study of law, his father offered his support, gave him advice on how to conduct himself in the art studio, and urged his son to copy the great masters of modern painting.

Lorenzo Pagans, a young Spanish artist who had already made a name for himself in Paris in 1869, often took part in the musical soirées organized by Manet and Auguste de Gas who, in his turn, was a dilettante organist and great music lover.

The portrait of Lorenzo Pagans and the artist's father remained dear to Degas, and he nostalgically conserved it following his parent's death. The painting is dated on the basis of a photograph conserved at the Cabinet des Estampes. The painter composed the portrait according to the canons of realist painting that were to be set down within the next few years by the art critic Edmond Duranty. The figures are connoted by both the actions that they make and the setting in which they are portrayed. For Duranty, in fact, the place in which the portrayed person is situated was fundamental to defining his personality. The setting says a great deal about the person, and the artist must not neglect this aspect, which is complementary to the physiognomic details.

The old man de Gas and the Spanish guitarist are placed in a family setting, sober yet welcoming. The furnishings have a warm color, and there are paintings on the walls and musical scores on the piano.

The subject recalls the great passion that Manet cultivated in the 1860s for the Spanish culture, when he did the painting entitled *The Guitarrero*, which Degas no doubt had seen and admired.

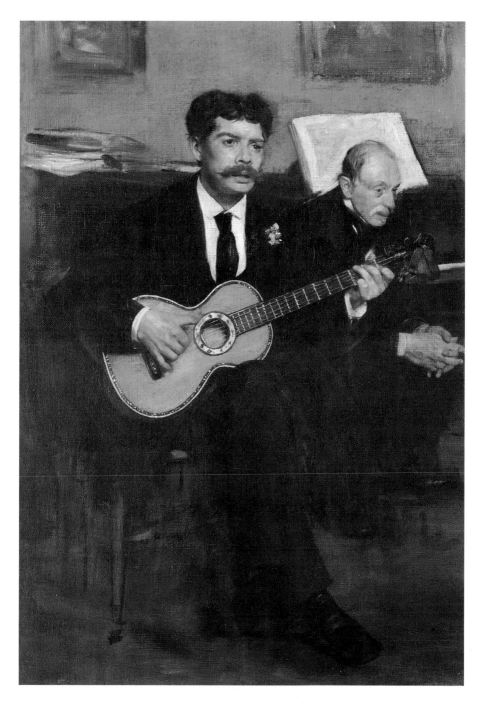

Marie Dihau at the Piano

1869–1872
Oil on canvas, 39 × 32 cm
Paris, Musée d'Orsay

The woman portrayed, Marie Dihau, was a famous pianist of Lille who often stayed in Paris and performed at the Colonne and Lamoureux concerts, which Degas and his father attended to listen to her. Toward 1872, Mademoiselle Dihau moved to Paris and it was in her home that her cousin, the painter Toulouse-Lautrec, met up with Degas.

The portrait that Degas made of the musician has an intimate, hushed quality. The perfection of the oval face and the well-balanced tonal values have led scholars to compare the painting with the portraiture of Vermeer, a seventeenth-century Dutch painter with whom Degas was no doubt familiar. In fact, in the portraits of these years, he was very careful to produce a feeling that, while starting with a realist connotation of the image, restored that feeling of intimate suspension and religious absorption that antique portraiture emanates. The many portraits he did in these years confirm Degas's "citation anxiety," peculiar to an artist who was still developing many different styles, as Lafenestre accurately noted in a review of 1879. The painter studied at length the painting of the seventeenth century, a period in which the portrait was often considered a private genre, often free of the hieratic, celebratory qualities typical of paintings with a commemorative function. The Dutch, especially, but also the French (in the seventeenth century La Tour, and the eighteen century Chardin) imbued their portraits with feelings that were not only intimate, but even of devotion, which was recovered in the second half of the nineteenth century, at a time when an alternative was being sought to escape the blind faith that the most dogmatic Positivism had brought to science.

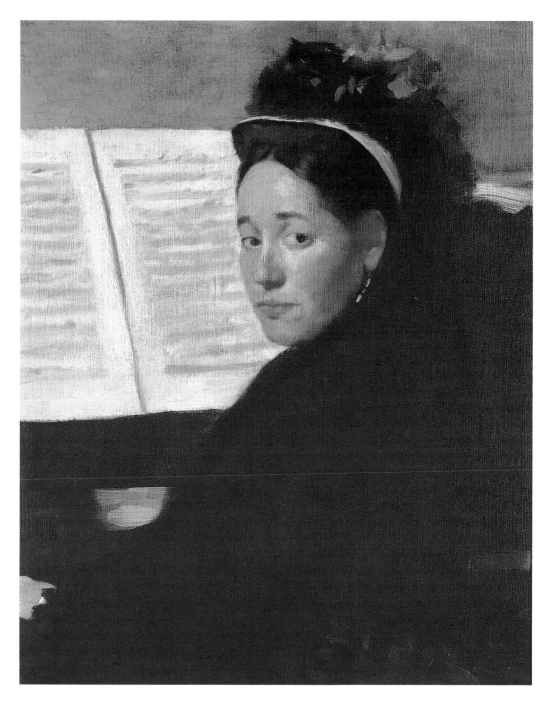

Jeantaud, Linet and Lainé

1871
Oil on canvas, 38 × 46 cm
Paris, Musée d'Orsay

The subjects portrayed had been Degas's comrades-in-arms in the siege of Paris during the Franco-Prussian war of 1870. In these years, the artist was strongly attracted by a new connotation of the portrait, captured in a setting that contributes to the definition of the subject. In a letter, Degas wrote: "Make portraits of people in typical, familiar poses, taking care in particular to match their body language to their facial expression. Thus, if laughter characterizes a dear one, let him laugh. There are, of course, feelings that cannot be rendered, out of decency, since the portraits are not just destined to us painters. How many subtle details to interpret!"

If we look at the portrait of the painter's friends, *Jeantaud, Linet and Lainé*, seated for conversation in a café, it looks as though the artist has captured an informal moment of an evening passed among friends and set it on the canvas. From his words we can understand how important the "pose" still was for him, and that he considered it with as much care as he had when he was a student at the École des Beaux-Arts, even if now the "pose" was adjusted to strengthen the supposed naturalness that the painting had to depict.

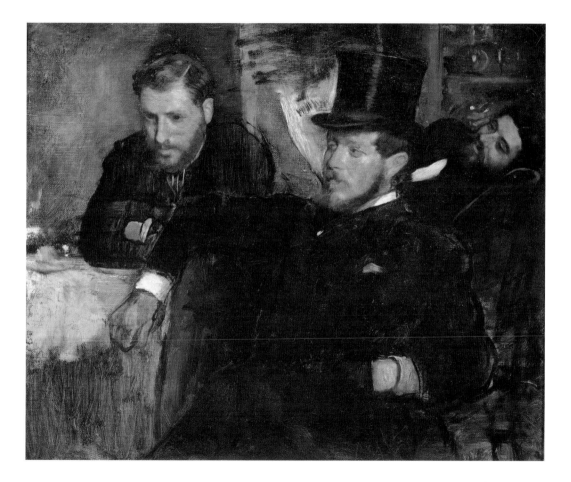

The Dance Lesson

1871–1874
Oil on canvas, 85 × 75 cm
Paris, Musée d'Orsay

The painting *The Dance Lesson* depicts a group of young ballerinas taking part in a lesson taught by a white-haired old man clasping a long baton. It is one of the first works that Degas dedicated to dancers. The painter arranged the girls in a semicircle around an increasingly foreshortened space. The joints in the parquet floorboards, which occupy much of the painting's foreground, accentuate the vanishing point. "Degas is one of the rare artists who have given importance to the ground," wrote Paul Valéry. "He has wonderful flooring. […] The ground is an essential factor in seeing things. The reflected light depends in great part on its qualities."

In agreement with the other impressionists, the painter started to contemplate the fact that no color is important in itself, but is influenced by all the colors that surround it. As a result, Degas's concept of form underwent an evolution in these years. However, Degas saw himself "on the fringes" of impressionism, as he would never completely sacrifice drawing—"to which his nature and education had destined him"—to the concept of form explored through the constructive possibilities of color; this path, instead, was the one taken by Cézanne in his solitary exploration carried out strictly *sur le motif*, directly from nature.

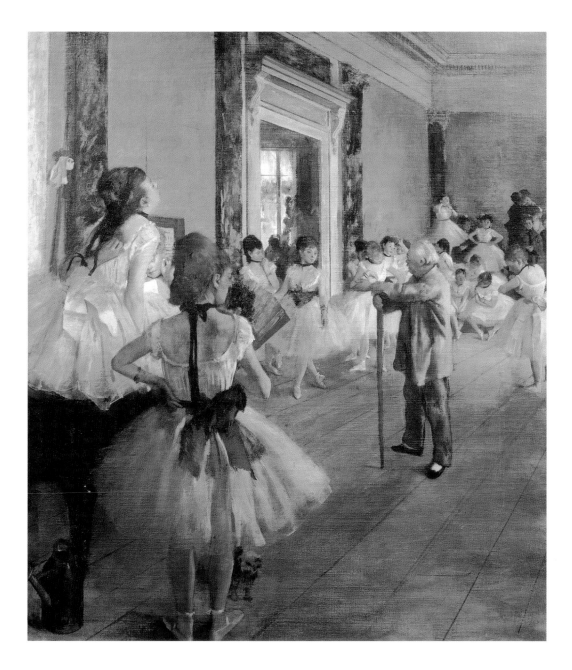

At the Races in the Countryside

1869
Oil on canvas, 36.5 × 55.9 cm
Boston, Museum of Fine Arts

The writer Edmond de Goncourt, after visiting Degas in his studio and having seen his works, described his impressions as follows: "What an original sort, this Degas: sickly, hypochondriac, with eyes so delicate that he is always afraid of going blind—and precisely for this, he is sensitive to the other side of life. I have never seen anyone who can show better than he modern life and its true soul."

The esteem enjoyed by the artist in these years can be attributed, in addition to his indisputable painterly skill, above all to his choice of subjects, which conformed to, and reflected, the preferences of the critics who championed subjects taken only from contemporary life, valued as genuine historical documents, as well as works of art.

Degas's contemporaries also considered his precise and nearly photographic-quality style excellent, and quite original, too, by reason of the compositional cropping he used, proposing fresh and dynamic visual takes instead of the frontal view, iconic and immobile, typical of earlier landscape painting. In fact, as Boston's Museum of Fine Arts *At the Races in the Countryside* shows, the symmetrical horizontal division of the horizon line is made dynamic by the device of leaving a part of the carriage in the foreground outside of the picture, so that the image presented seems less studied and more casual. In any case, even if the impression given by the painting is one of an accidental sight, the painter studied, with enormous care, the picture's sense of balance in terms of both color and composition, which also contributes to creating this feeling of fortuitousness.

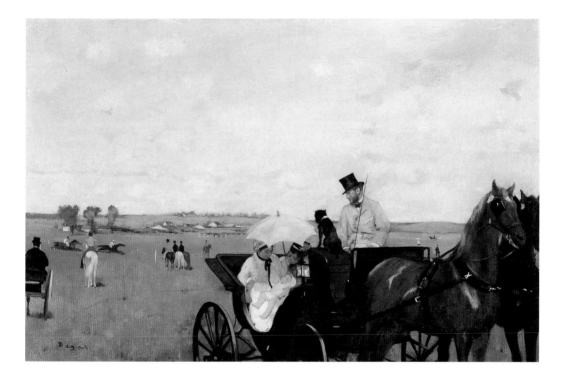

A Cotton Exchange in New Orleans (Portraits in an Office)

1873
Oil on canvas, 74 × 92 cm
Pau, Musée des Beaux-Arts

In 1872, Degas traveled to New Orleans with his brother René. He painted his famous *A Cotton Exchange in New Orleans* in his American relatives' company, and took it back to France with him. During his visit to America, the artist wrote an enthusiastic letter to his painter friend Lorenz Frölich: "Here, it all fascinates me, I look at everything […]. There is nothing I like more than the black ladies of every shade, holding in their arms white babies, so white, against a backdrop of white houses with fluted wooden columns or in orange groves; and the women in muslin dresses in front of their small houses, and the *steamboats* with two chimneys as high as factory smokestacks, and fruit vendors in crowded shops; and the contrast between the busy, meticulously neat offices and this immense Negro animal strength, etc. And the charming thoroughbred women; and the attractive mulattos, and such buxom blacks!"

The painting *A Cotton Exchange in New Orleans* was shown at the second impressionist exhibition in 1876. The precision with which the painter portrays the scene, in which the black and white hues dominate, reveals the influence that Manet's scenes from everyday life had on Degas. Manet, who had let himself be seduced by foreign painting from seventeenth-century Spain and Holland, later focused on subjects taken from street life.

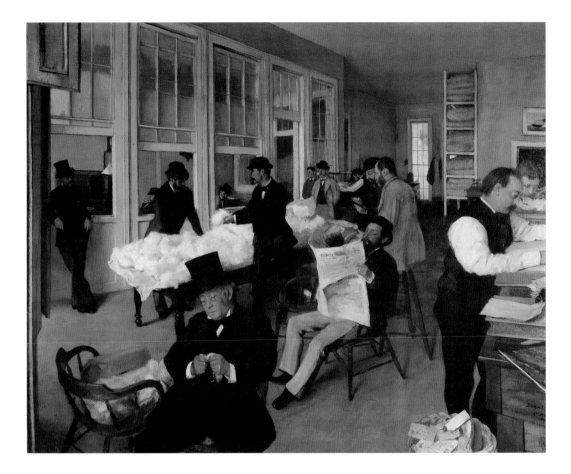

The Pedicure

1873

Peinture à l'essence on paper
mounted on canvas, 61 × 46 cm
Paris, Musée d'Orsay

Degas tirelessly experimented with formal solutions, but his curiosity also led him to try out different possibilities in the area of the artistic media used. While Monet, for example, painted with oil on canvas throughout his life, Degas often drew and painted on paper. He had acquired this love for a support as fragile as paper in his youth, when, not feeling "ready" to make paintings, he sought counsel and wisdom from the great masters by copying an enormous number of drawings. In the youthful years of his stay in Italy, Degas confided to his friend Gustave Moreau: "[…] the best thing to do is to use your time studying the profession. I could not begin with anything of my own. It takes a great deal of patience in the path I have chosen. […] No consolation is provided by progress and youth, except a bit of illusion and hope."

In the work *The Pedicure*, the painter does a portrait according to realist criteria, since it shows a subject drawn from everyday life, worked out in the domestic calm of an upper-class household of the time. In some way, this subject anticipates the many works that the artist was to do on feminine grooming. In the late works, which have as their subject intimate body care, he was to become ruthless in his unmasking of the human figure's inelegance, but in this work, which is still early, conserved at the Musée d'Orsay, he conceals the nudity of the girl with a white fabric, keeping his handling of the subject within the limits of convention.

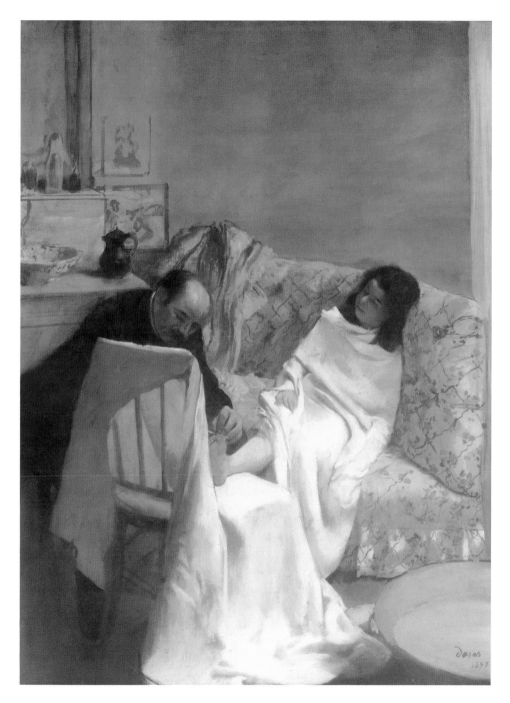

Ballet Rehearsal on the Stage

1874
Oil on canvas, 65 × 81 cm
Paris, Musée d'Orsay

In Degas's dancers, the grace, the elegance, the stage costume veils, the transparency, the whites, the soft fluttering of the hands and legs, all this contributes to heightening expectations before the magic moment of the ballet performance. The fantastic and the real, the harmonic and discordant all together are elements that contribute to making *Ballet Rehearsal on the Stage* an extraordinary work, perhaps the most suggestive canvas of ballerinas that Degas ever painted. The stage is viewed from above, wrapped in a radiant light that freezes the dancers' snow-white costumes and the flesh tones of face and limbs. In the wings, the space recedes into shadow, while in the foreground it is bathed in a brilliant dazzle, accentuated by the curve of the stage delimiting the border with the orchestra pit. The monochrome is the harmony the painter sought, starting from dark browns and brightening gradually up to the whites that seem to radiate light from within. There is a suggestion of the magic of the daguerreotype, the light-sensitive silver plate that was used in the earliest photographs. Photographic-like, Degas is pitiless in drawing the faces for such fragile little figures, faces that twist into grotesque expressions, or coquettish smirks. In this work the painter seems to be laying down a challenge to photography, the great rival of painting, to immortalize reality with an impeccable gaze. But we know from observers that Degas's working method required him to make constant revisions of his works, which he never considered finished, and could not have been more antithetical to a procedure that made it chemically possible to fix an image on a support without permitting further improvements.

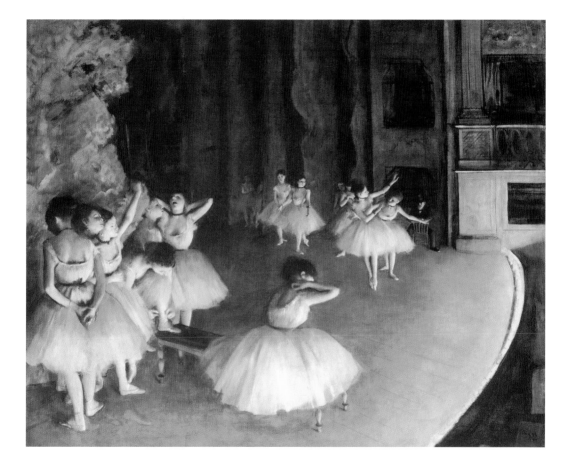

The Orchestra Musicians

1874–1876
Oil on canvas, 69 × 49 cm
Frankfurt, Städelsches
Kunstinstitut und Städtische
Galerie

Looking at impressionist paintings, the sensitive critic Philippe Burty wrote in 1874: "Although the sensations captured are at times as fleeting as the sensation of the cool of the underbrush, of the wave of heat from a cabin, of the stillness of an autumn evening, of the scent of a beach, of a blushing cheek or a reflection of a dress, we must in any case be grateful to these artists for seeking them out and depicting them. In this way, their work has connection with that of the old masters. […] Is not Degas a classic in his own time? There is no surer hand for interpreting the sentiment of modern elegance."

The painting *The Orchestra Musicians* captures exactly this feeling of transience. The artist showed the moment of the prima ballerina's bow to the public. The musicians in the foreground, who occupy the lower half of the picture, seem enormous compared to the distant, minute ballerinas on the stage. In this work, which accomplishes complex balancing acts in terms of both color and composition, Degas reveals a great talent in the use of color: the dark, decisive blacks of the musicians' suits, outlined by the intensely white collars, are offset by the iridescent, luminous colors of the stage, where frothy, white ballet costumes glow before the dappled backdrop.

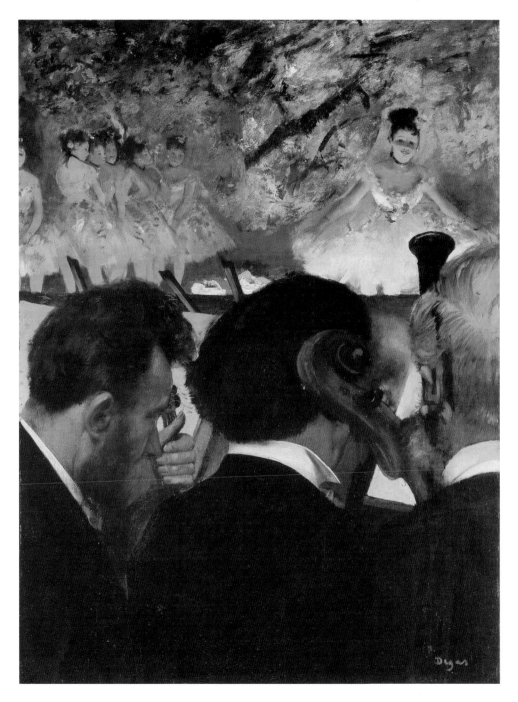

Woman Ironing
(La repasseuse)

1875
Oil on canvas, 25 × 19 cm
Pasadena, Norton Simon
Museum

The Pasadena *Repasseuse* is one of a series of canvases depicting women ironing, laundresses, and common people who were the subjects for many artists during the late nineteenth century.

In French painting, subjects of this type had been explored around mid-century by the likes of Millet, Daumier, and Courbet. The interest that Millet had, in about 1850, for country life with its workers shifted, by about 1860, with Daumier, to the hard work that was done on the banks of the Seine, where the tireless washerwomen are depicted in their shabby clothes. Compared to the merry washerwomen portrayed in the eighteenth century by Fragonard, Boucher, and Hubert Robert, Daumier's bore a message of sadness and hardship kept in check by their dignified resignation to their lot.

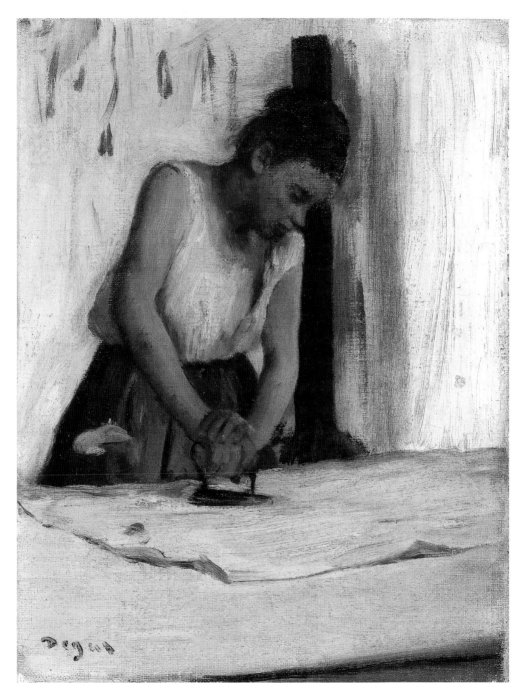

115

Henri Rouart in front of His Factory

c. 1875
Oil on canvas, 65.6 × 50.5 cm
Pittsburgh, Carnegie Museum
of Art

Henri Rouart, engineer, art lover, and painter, had close ties to Degas; he was, that is, a member of the restricted public to whom Degas addressed his art and his soul. In Paul Valéry's writings we find a masterful description of the personalities of both Degas and Rouart: "I met Degas at Henri Rouart's home, sometime around nineteen ninety-three or ninety-four, introduced to me by one of his sons [...]. That building in Rue de Lisbonne, from the entrance to the attic, was a complete succession of first-rate, exquisite paintings. [...] In Rouart, I admired, I revered, the fulfillment of career in which all the virtues of his character and mind were merged. Neither ambition, nor envy, nor the impulse to ostentation have ever tormented him. He cared only for true values, which he was able to appreciate in more than one area. [...] He divided himself between metallurgical research [...] and a passionate interest in painting. [...] if it was a matter of painting, it was Degas who he consulted. He adored and admired Degas. They had gone to school together at the Lycée Louis-le-Grand, but fell out of touch for years. A strange twist of fate brought them together again, [...] in 1870, with Paris under siege [...] Every Friday, Degas, dependable, entertaining, intolerable, enlivened the dinners of the Rouart home. He sowed wit, terror, and cheer. He offended, mimicked, was expansive with his quips, his apologues, adages, tall tales, all the latest: the cleverest insult, the surest taste, the most coherent passion, and also the most lucid [...] And his host, who adored him, listened with indulgent admiration [...]."

In accordance with the principles of realistic portraiture, Degas depicts his friend in front of his factory. Rouart, shown in profile, occupies the foreground of the canvas. He is represented as a cool and distinguished man, whose personality was divided between his passion for art and his profession. The painting's colors stay in the somber range, conferring a serious and dignified appearance to the image.

116

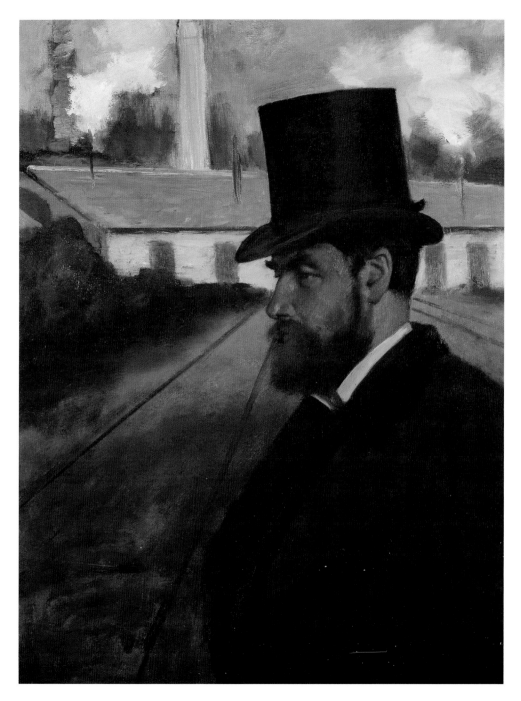

Madame Jeantaud at the Mirror

c. 1875
Oil on canvas, 70 × 84 cm
Paris, Musée d'Orsay

Degas experimented with different compositional elements that he could use in the portrait genre, which was one of his favorite themes in painting, sampled in his early years and never abandoned. The painter Berthe Morisot told how Degas always said that "the study of nature was insignificant, since painting was an art of conventions, and that it was much better to learn to draw from Holbein." The painter often referred to the great portraitists of tradition, while remaining true to his principles of realism. After all, the art of the portrait can be considered the genre that has always required some fidelity to the model, despite the diversity of interpretations given it over the centuries.

The portrait of *Madame Jeantaud at the Mirror*, while keeping all the freshness of a moment of everyday life stolen from the privacy of a woman, proposes the iconographic motif of the "portrait in the mirror," so dear to modern painting, from the Renaissance on. Madame Jeantaud is portrayed in profile, while her image is reflected in the mirror. Her gaze turns to us through the looking glass and focuses on the "ideal" observer, who is outside of the painting. Her hands clutch a muff that she hugs to her front. The young woman is elegantly dressed and seems just about to leave the apartment, or, to the contrary, she may have just come back home.

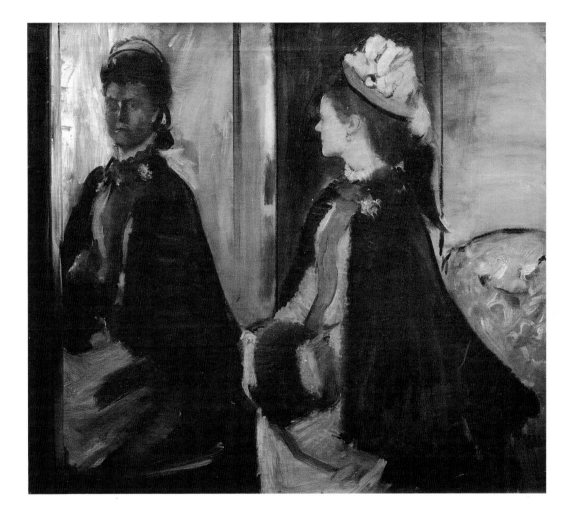

119

Ballerina Posing for the Photographer

c. 1875
Oil on canvas, 65 × 50 cm
Moscow, The Pushkin State
Museum of Fine Arts

In the essay Valéry dedicated to Degas, we read: "Degas has a curious sensibility for *mimicry*. After all, the ballerinas and woman ironing that he painted were captured in positions significant to their occupations, which permitted him to renew the view of their figures and to analyze many poses that painters before him had never before considered. He abandoned the beautiful women softly reclining, the delicious Venuses and odalisques; he never tried to arrange on a bed some obscene and sovereign Olympia […] Instead, he assiduously worked on reconstructing the specialized female animal, slave of dance or of starch, or of the sidewalk; and those figures, more or less deformed, which he obliges to assume rather unstable positions for their articulated structure […], suggesting that the entire mechanical system of a living being can smirk like a face."

In the painting *Ballerina Posing for the Photographer*, the dancer's pose is not harmonious. The ballerina is surprised as she is trying to find a lovely position looking at herself in the mirror, and Degas chooses to represent her just at the instant when, arranging herself, her limbs assume almost a grotesque appearance. The writer and art critic J. K. Huysmans was to say that Degas paints his ballerinas with "horror." Perhaps that is going a bit too far, but it remains true that the painter—apart from a few cases in which he showed a charm only a man as refined as he would know how to dose in the right measure—most often interpreted the female figure as if with anger, explicitly refusing to make it beautiful.

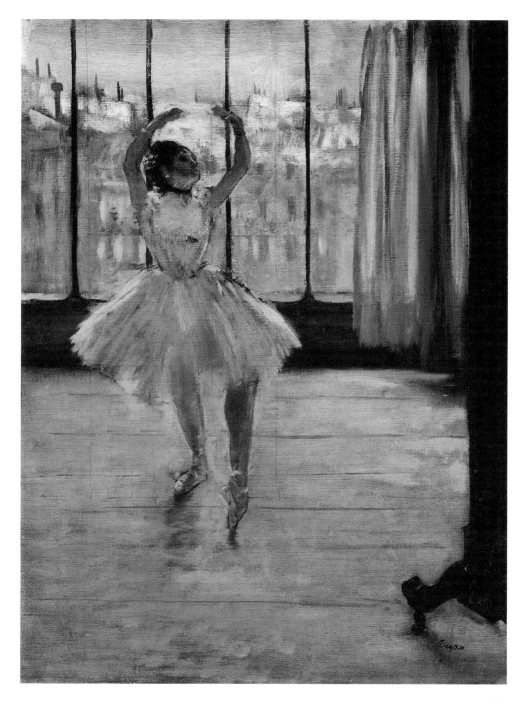

The Glass of Absinthe

1875–1876
Oil on canvas, 92 × 68 cm
Paris, Musée d'Orsay

The canvas originally entitled *In a Café*, and today known as *The Glass of Absinthe*, was shown at the second impressionist exhibition, in 1876. The subject shows an episode of city life and falls under the range of urban themes taken up by all the impressionists. However, the isolated and lonely interpretation that Degas gives of café life is far from that of either Manet, who was an assiduous habitué of the crowded, merry cabarets of Paris, or Toulouse-Lautrec, who liked to portray the uncouth protagonists of the pleasures of the nightlife. In *The Glass of Absinthe*, Degas paints two figures seated next to one another, each absorbed in his and her own loneliness and social exile. To enhance the sense of isolation, the painter relegates the two figures to the right-hand side of the canvas, and leaves the center to the stark appearance of the foreshortened table, upon which sits a forlorn empty carafe. To make the painting, Degas took as his models the actress Ellen Andrée and the painter and engraver Marcellin Desboutin. Both also sat for Manet, who depicted Marcellin Desboutin standing, with the attitude of a perfect exponent of Parisian *bohème*, and Ellen Andrée in a work entitled *At the Café*, where the euphoria and the *joie de vivre* stand in utter contrast to the feeling of silent despair that emerges from the absent gaze of the woman in Degas's painting. The lonely drinker has before her a glass full of Absinthe, a greenish liqueur flavored with mint and anise that is prohibited today, but was quite common in the mid-nineteenth century. Valéry was to say about Degas's talent for painting loneliness that the painter himself had lived most of his existence nearly without company, perhaps precisely because of the "dark outlook of his [that] saw nothing in rose."

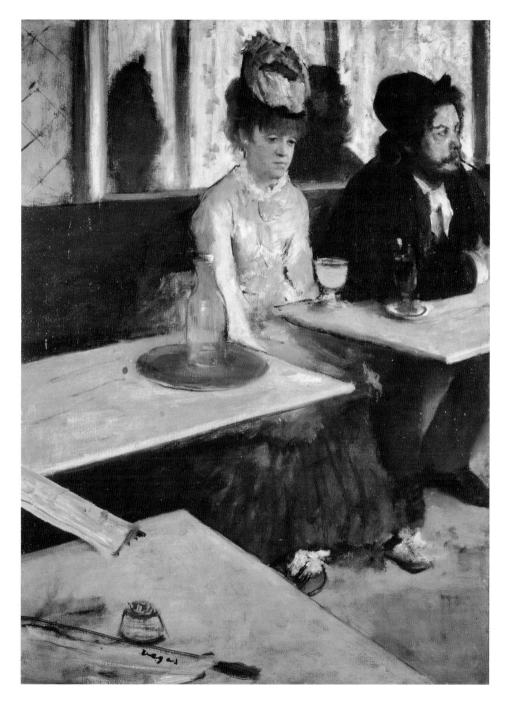

Café-Concert aux Ambassadeurs

1877
Pastel, 37 × 27 cm
Lyon, Musée des Beaux-Arts

Before doing such paintings as *Café-Concert aux Ambassadeurs*, Degas did several drawings in which he studied, for example, the stance of the chanteuse. The painter quickly sketched a half-dozen poses for each sheet, which helped him to "work out visually" his subject. Then he chose the sketch that seemed to him to correspond best to the atmosphere of the scene, and around it arranged the entire setting. From a spatial point of view, the compositions that he invents derive from the great examples of modern painting. Some perspective solutions take their inspiration from sixteenth-century Venetian painting, especially from Veronese and Tintoretto. When Duranty harshly criticized the *passé* world of the canvases produced by the École des Beaux-Arts milieu, he contrasted the anachronism of that institution with the truth that can instead be found in the works of Veronese, who illustrated biblical episodes, illuminating "these ancient things with the flame of contemporary life." According to the critic, "Veronese's *Marriage at Cana* would have been pathetic without the Venetian gentlemen."

In the *Café-Concert aux Ambassadeurs*, Degas suggests the idea of the show in progress by using a low perspective that permits the observer to focus attention immediately on the *soubrette*.

Georges Rivière reviewed the painting in 1877, on the occasion of the third impressionist exhibition: "One of the *Café-Concerts*, the one with a woman dressed in red, is wonderful. How skillful the rendering of the women in the background, in muslin dresses with their fans, and the public in the foreground, watchful, heads erect, necks stretched, all paying attention to a rakish chanson and provocative gestures! […] The woman does not have what the actors call a "line"; no, she turns to the public, questions it, sure that it will answer according to her wishes, answer her, mistress of the tyrant, whose vices she gratifies."

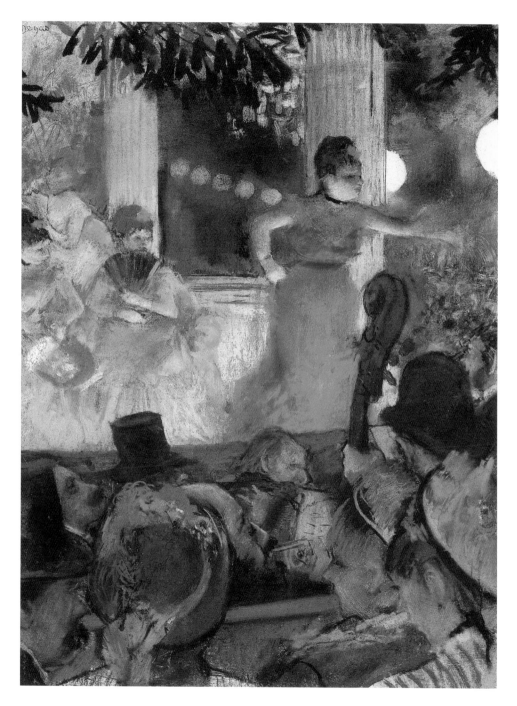

Ballerina with Bouquet Onstage

c. 1877
Pastel and gouache on paper,
72 × 77.5 cm
Paris, Musée d'Orsay

This pastel, with its sunny, exotic quality, has a bright and transparent range of colors. The *étoile*, bouquet in hand, makes her curtsey under a harsh light that flattens the figures and gives them a bleached look.

The pastel works highlight Degas's masterful use of color. The artist seems to discover, within each of his pastel drawings, a sort of geometry that shapes the unity of the composition. He constructs his own universe, each time newly reconsidering the figure, from a different point of view and under different lighting conditions. This way of examining reality, which was common to all the impressionists, led each one of them to different results, determined by the given of the relativity of sight.

In making his investigation of the human figure, Degas felt a need to experiment with sculpture, which allowed him to recreate the object in three-dimensional space. We cannot hazard an assessment of this master's work without considering his great versatility. He used pastels because they made it possible for him to achieve more immediate effects than oils did; also, they allowed him to probe persistently the intrinsic potential of drawing, which Degas perceived as his main tool for producing reality. For Degas, color was never "constructive," as it was for Cézanne. In fact, the path that Degas opened up for the future generation of artists was the direction taken by the Nabis painters, whose decorativism was already there in his pastels of the 1880s to 1890s; instead, the seed that Cézanne planted was reaped by the cubists, to decompose and recompose reality in an illusionist, spatial way.

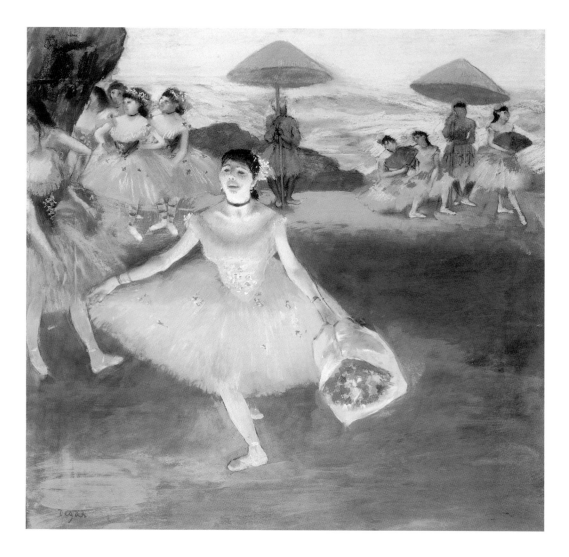

Fin d'arabesque
(Ballerina with Bouquet)

c. 1877
Peinture à l'essence with pastel
highlights, 65 × 36 cm
Paris, Musée d'Orsay

The work *Fin d'arabesque* is one of the many canvases with ballerinas that Degas did in the 1870s revealing his keen interest in positions assumed by the human figure. To understand Degas's method for studying figures in movement, it is useful to look at a series of notes the artist made for himself, almost memos, before he got to work.

Degas jotted in his notebooks: "Do simple things, like draw a profile that is not moving, moving ourselves, going up and down for the entire figure, a piece of furniture, a living room, the whole thing. [...] Do a series of arm movements in dance, or legs that do not move, turning around them... etc. Finally, study a foreshortened figure, or object, or anything [...] Leave a lot out: of a ballerina, do the arms or the legs, or the small of the back, do the slipper, the hands of the hairdresser, the snipping of the hair, bare feet dancing... etc." These annotations allow us a glimpse into the analytical process Degas used with respect to his subject. However, the result achieved in the work reveals none of this dissection of the figure through drawing. The effect is of an instinctive visual process successfully carried out by a genius who, inspired, spontaneously did the work of art. This sort of interpretation, however, does not apply to the work of a painter whose scientific approach had been noticed by his contemporaries, some of whom even seemed to be disturbed by his reflections on the human figure; they grumbled, in fact, that such studies looked as though they had been composed more by a zoologist than an artist. It is no coincidence, then, that Valéry should remark, "Sometimes [Degas] depicts a ballerina from a very high point of view, and her whole figure is projected on the plane of the stage, like when we see a crab on the beach. This permits him to use new perspectives and interesting combinations." Degas often used this angle in canvases with ballerinas.

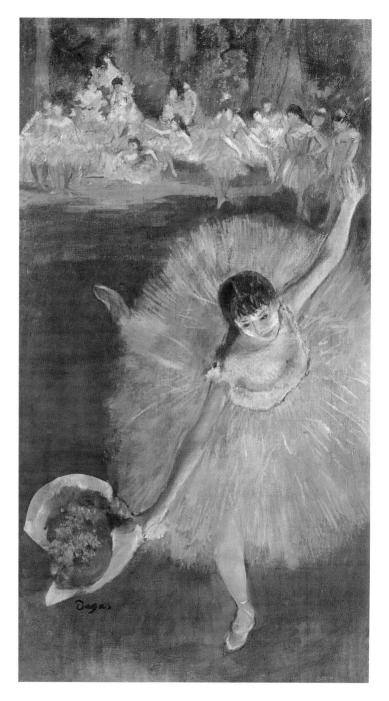

Women in a Café

1877
Pastel, 54.5 × 71.5 cm
Paris, Musée d'Orsay

When, in his youth, Degas decided to abandon historical subjects and take the route of realism, his culture prevented him from lapsing into the stark observation of life around him. He worked out a compromise by putting into the representation of modern life the carefulness that he had been able to study in the great painting classics. When he started to use pastels, which requires greater executive precision than oils as it cannot be corrected by covering one image with another, he was able to capture effects that demand extraordinary talent, such as the glimpse of the street at night sparkling with lights, behind the ladies in *Women in a Café*. After all, the pastel medium perfectly complements the affinity for drawing that the artist had cultivated since the early years. With a sure hand, he defined the four women sitting in a city café chatting. He captured their worldly, fatuous expressions and destroyed their presumed elegance with the gesture, hardly decorous, of the woman in pale blue at the center. Stern and disapproving desecrator of city-dwellers' leisure activities, Degas often laid bare the spiritual hypocrisy of the people he chose as the protagonists of his paintings.

Georges Rivière mentioned the painting in his review of the third group exhibition published in *L'Impressioniste. Journal d'art:* "Then, here are these women at the window of a café, in the evening. One, picking at her teeth […]. Another spreading her gloved hand on the table. In the background, people on the *boulevard* disperse little by little. It is, once again, a truly extraordinary page of history."

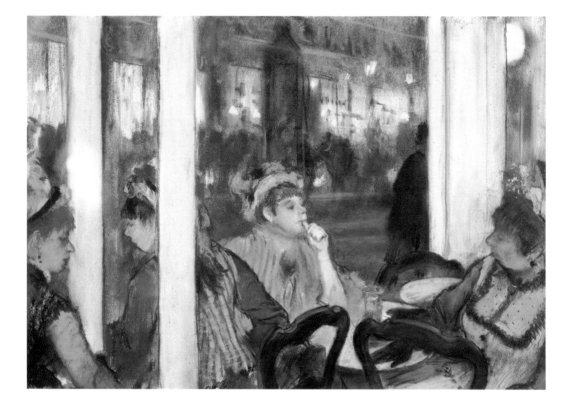

Carriage at the Races

1877–1880
Oil on canvas, 66 × 81 cm
Paris, Musée d'Orsay

The scene shows amateurish sport among jockeys, watched by a few people sitting in a carriage. The chance spectators are only half-visible in the visual field of the composition; indeed, only a part of the carriage appears in the foreground, to the right. The painter organized the space on three planes of depth: the carriage occupies the first one, the racing meadow the middle one, and the landscape stretches out in the distance. On the field, the horses are captured in movement. Degas was one of the first to study the various aspects of this agile animal, making use of the snapshots taken by Major Muybridge. "After all," wrote Valéry, "[Degas] loved and appreciated photography in an era when artists disdained it or dared not use it." Degas was an accomplished photographer himself.

The horse fascinated him, as an aristocratic, powerful animal, swift and sleek, "nervously nude in its silky coat," as the artist described it. He discovered in the horse, as he had earlier in the ballerina, something that came close to his own temperament: a pure being, a "classic" surviving in contemporary reality. Degas considered the horse a noble, elite subject that could unquestionably seduce an artist who is led by his very nature to make "exquisite choices," both in life and in art.

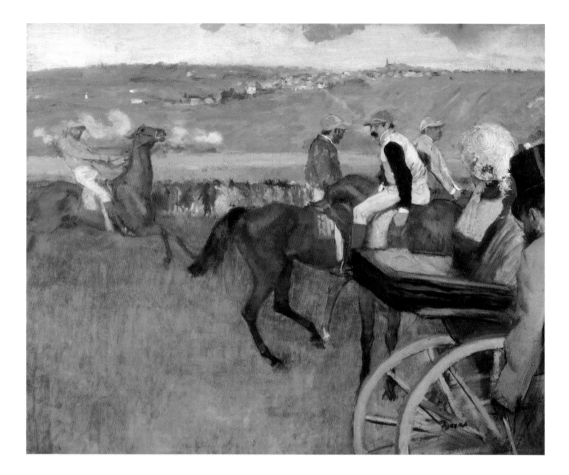

The Painter's Friends in the Wings

c. 1879
Pastel and tempera on paper,
79 × 55 cm
Paris, Musée d'Orsay

"A picture is a thing that requires so much cunning, astuteness, and vice, it is like committing a crime; you need to falsify and then add to it a pinch of nature." This is one of the rare phrases Degas uttered about his own concept of art. The almost "inquisitorial" mania—as Francastel described it—which leads to pure voyeurism is, substantially, the role that Degas assigned to painting in his late years. He held public esteem at arm's length; this aloofness with respect to the limelight was also a consequence of his difficult character, which rarely managed to find grounds for socialization with his fellow creatures. Once, he answered a journalist: "Painting is done to be seen? Get this clear, you work for two or three living friends, for others who you don't know or who are dead. Is it any concern of journalists whether I paint boots or cloth slippers? This is a private matter."

In the picture _The Painter's Friends in the Wings_, he presents precisely the theme of voyeurism, since it is the curious gaze of the painter that surprises the two gentlemen talking in a part of the theater reserved for insiders. The space is vertically divided by the stage wing, and diagonally by the edge of the floor. One of the two men can be seen in full, while the other is half-hidden by the scenery flat. The composition is very simple: there are few elements and few colors. But it is just this supposed simplicity that conceals a meticulous, exhaustive pursuit of highly delicate balances, and made up the greatest reason for anxiety within the painter's artistic course.

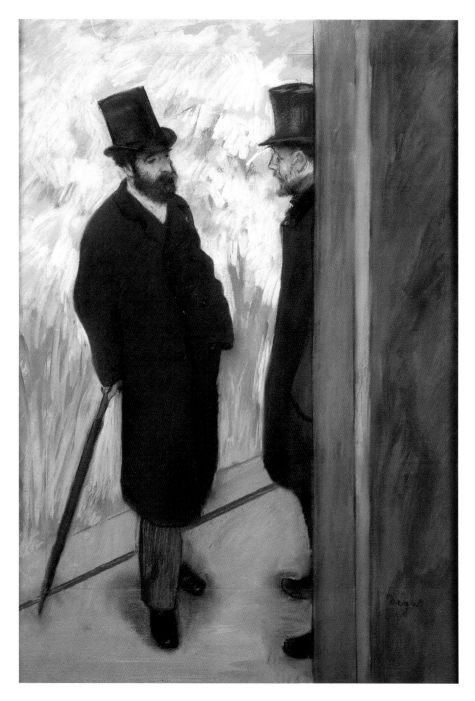

Miss La La at the Cirque Fernando

1879
Oil on canvas, 117 × 77.5 cm
London, National Gallery

The circus, like theaters and cafés, was a subject that greatly aroused Degas's curiosity. In January 1879, he made various studies of the acrobat Miss La La while she was doing her number at the Cirque Fernando in Boulevard Rochechouart. The painting appeared at the fourth impressionist exhibition in 1879. At that time, impressionist painting was still regarded by most critics with a certain diffidence. George Lafenestre reviewed the exhibition in *Revue des Deux Mondes*, eschewing the ironic tones used in the earliest reviews, but still interpreting impressionism as a sort of naïf language that took its inspiration from Japanese painting. Among all the artists exhibiting, the ones Lafenestre most appreciated were Mary Cassatt and Degas. "Degas and Miss Cassatt are […] the only artists who stand out in the group of the Independents; the only ones who give some pleasure and some justification of the pretentious display of sketches and infantile prattling, in the midst of which it is almost surprising to meet up with their hastily done, but keenly alive canvases. Both have an exact sense of the decomposition of the light in Parisian interiors […]. Degas, more mature and more skilful, also has a certain experience in draftsmanship, which from time to time, he uses, but cannot manage to hide. As a painter of contemporary life, he could hold a good position, but it is hard to see how he would hold it using different methods, and how, on the other hand, a man who cleverly combines the imitation of the English watercolorists with the imitation of Goya, can seem more independent than his comrades of the Champs-Élysées […]."

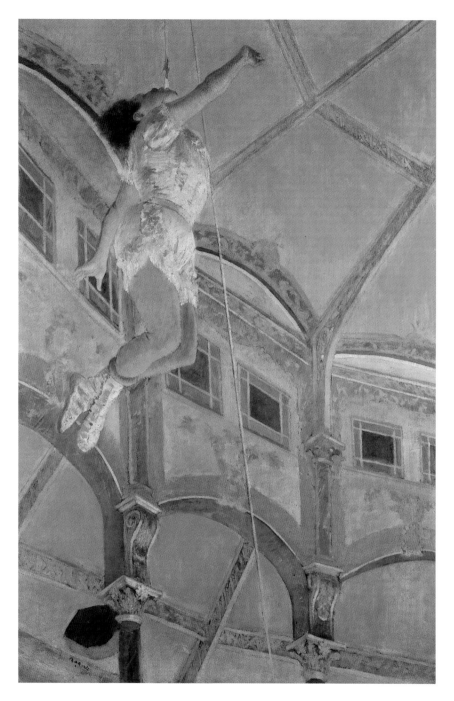

Portrait of Diego Martelli

1879
Oil on canvas, 110 × 100 cm
Edinburgh, National Gallery
of Scotland

Diego Martelli was the Italian critic friend of the Macchiaioli, the group of painters who met in Florence at the Caffé Michelangelo in Via Larga, beginning in the mid-1850s. In 1878, Martelli visited Paris and met Edgar Degas, who did two portraits of him. While in Paris, Martelli came into contact with the impressionist group and was enthusiastic about the innovations these painters proposed. Stimulated by what he had seen in the studios of some of the artists, Degas for one, he looked into the theoretical side of the movement and when he returned home, in 1878, he held two conferences at Livorno's Circolo Filogico, where he demonstrated to have perceived before anyone else in Italy the magnitude of the impressionist movement. In one of the conferences, he described the French movement as "the dawn of the future" in painting. He tried to explain to his public what he had drawn from the essay *La Nouvelle Peinture* written by Edmond Duranty, art critic and champion of the impressionists. Unfortunately, Martelli's thorough and philological explanation did not meet with great approval among his painter friends, who did not share his enthusiasm. Some, like Giovanni Fattori, even came to ridicule the fine painting by Pissarro that Martelli had brought back with him from France, today conserved at the Galleria d'Arte Moderna in Florence.

Degas's *Portrait of Diego Martelli*, done in 1879, shows the critic seated with arms folded across his chest, with a pensive expression on his face. To his left, on a greenish chest are scattered books and reviews, along with a few other objects that cannot be made out simply because they are only roughly sketched. The perspective seems to tip the composition forward, and it is viewed from a high angle. Degas often used this device, which gives the scene a more dynamic appearance.

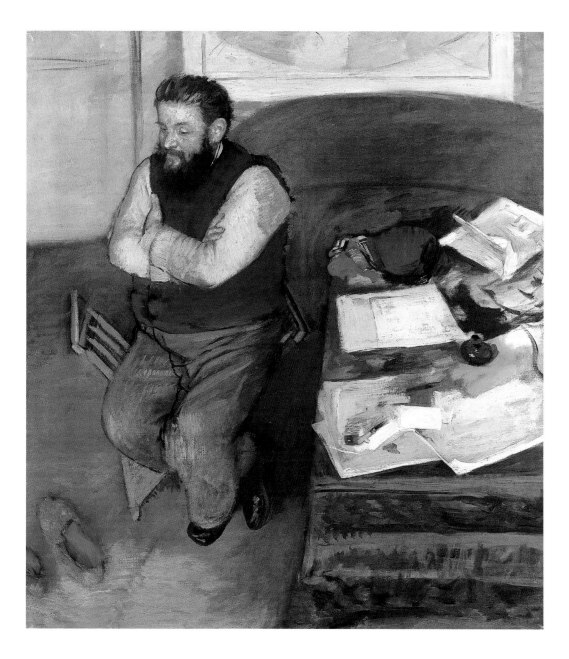

At the Milliner's
(Mary Cassatt)

*c.*1882
Pastel, 67 × 67 cm
New York, The Museum
of Modern Art.
Gift of Mrs. David M. Levy.
Digital Image © 2002 Florence,
The Museum of Modern Art,
New York/Scala

Charles Baudelaire was deeply aware of the relationship between the new sense of space and time permeating big city life and the artist who with great creative anxiety sought to set contemporary life on the canvas. "He [the artist] seeks that something that we must be allowed to call *modernity*, since there is no other better word to express the idea to which it refers. The secret, for him, is to distill from fashion whatever it might contain of the poetic in the fabric of everyday life, to extract the eternal from the ephemeral."

The artist's role with respect to the representation of the present day raised heated debate among critics of the second half of the nineteenth century. In his early years, Degas had applied himself to ancient history painting, but he soon abandoned such subjects to concentrate on the representation of life he could observe around him. If, a few decades earlier, an artist had proposed a subject such as the one Degas presented in *At the Milliner's*, observers would not have tolerated seeing depicted "a moment like any other in the life of an insignificant Parisian milliner." Painting, like literature after all, had to (according to the opinion of conservative critics) deal only with things "worthy" of being represented. This aristocratic and elitist view of history was overturned by an entire series of intellectuals (artists, philosophers, poets, and novelists) who, around midcentury, asserted through their work the importance of being contemporary. Gustave Courbet, leading exponent of the realist current, wrote in his *Manifesto of Realism*: "[…] art or talent, in my opinion, should only be for the artist a means for applying his personal skills to the ideas and the things of the time in which he lives. In particular, the art of painting can consist only in the representation of the things that the artist can see and touch."

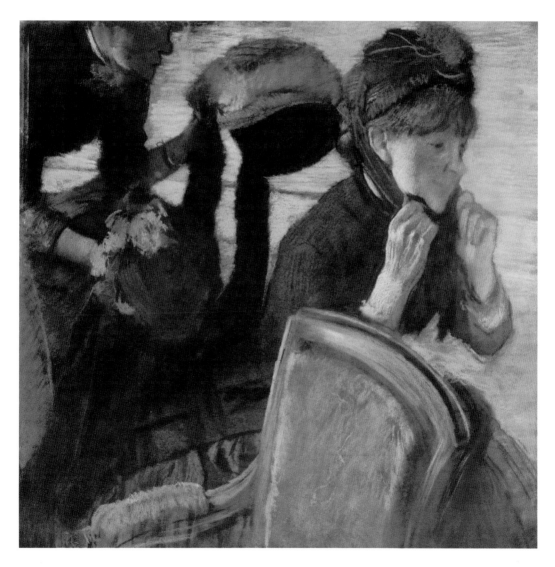

Ballerinas

1883
Pastel, 64.8 × 50.8 cm
Dallas, Museum of Art

Only rarely did Degas depict ballet at the height of its effect: he preferred to describe the phase of preparation, where he often took the opportunity to unmask the awkwardness and physical limitations of the dancers, finding a new form of beauty in this pitiless display. Even when he started to draw female nudes, Degas did not abandon the ballet motifs; indeed, he tended to consolidate the old subjects through his anatomical studies.

At first, the artist had reproduced ballet themes with a more pictorial interest, drawing the figures with great care and many details, but later he devoted himself to the study of nude figures that he would then do over, now dressed. The nude permitted him to concentrate on actions in a more synthetic way. Perhaps this procedure found its way into his painting thanks to the influence of sculpture, which he was exploring in the same period, and which he studied for the realization of his pictures.

From a passage by the journalist Thiebault-Sisson dating from 1897, we learn that during one of their conversations, the painter talked about his experiments in modeling. Referring to his studies of horses, Degas said: "The older I get, the more I realize that to achieve an interpretation of the animal, a precision so perfect as to give a sensation of life, it is necessary to resort to the third dimension, and not just because the work of the modeling requires thorough observation on the part of the artist, a capacity for keeping attentive over a prolonged period, but because approximations are not admissible."

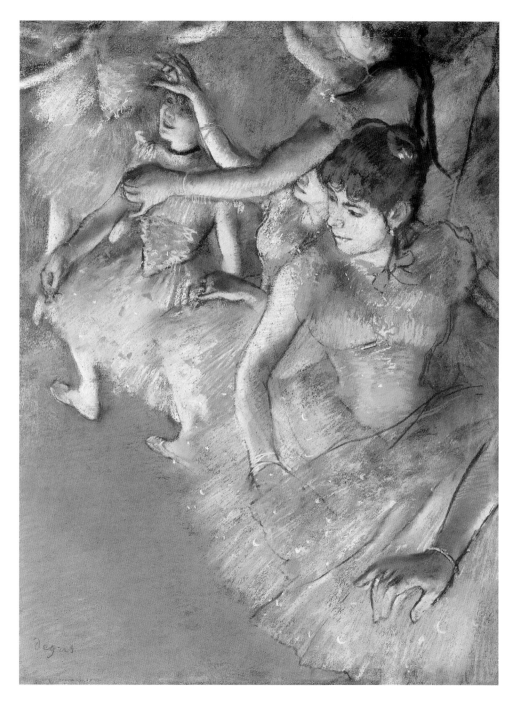

Woman Bathing

c. 1883
Pastel (or pastel over
monotype), 19 × 41 cm
Paris, Musée d'Orsay

Some scholars include *Woman Bathing* among the pastels done on paper; others place it among the monotypes using pastels. In any case, it all goes to confirm the artist's great versatility in terms of the techniques he used. We know from Degas's letters in the 1880s that he was working with engravings, an artistic technique that he had been familiar with since his youth. We read in a letter to Pissarro: "Here are the engraving proofs: the overall blackish, actually yellowish, hue comes from the zinc, which is already oily in itself and absorbs some of the printer's blacks [...]. You can see for yourself how much potential this process has. You should also practice using grainy textures to get, for example, a uniformly gray sky, even and delicate. [...] Your soft paint seems a bit too oily to me. You overdid either the oil or the tallow. [...] As for the color, I shall run off some copies with a colored ink of the proofs you'll be sending me. I still have other ideas for color engravings."

These few remarks demonstrate Degas's thorough command of the technique. There is no doubt that the engraving procedure came to influence the artist's handling of the edges and the proportions of the nudes he did in pastels, where there is a progressive distortion of the figures depicted, a process that may have stemmed from the discovery of the expressive potential inherent in this artistic technique.

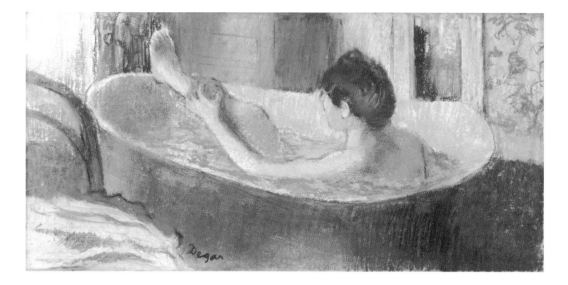

After the Bath

1884
Pastel, 50 × 50 cm
St. Petersburg, The State
Hermitage Museum

This study of a woman drying herself after her bath is interesting for the model's pose, which was never reproposed in any of the many versions of this subject. Some scholars believe that the pastel was shown at the last impressionist exhibition, in 1886. However, as no copy of the catalogue has survived, we cannot be certain. The pastel is certainly of a high quality, both for the complexity of the pose depicted, and for the attention to decorative detail, for example the delicate pattern on the wallpaper, which lends an elegant tone to the composition. The line drawn round the woman's silhouette is heavier in some points and lighter in others, to indicate through the outline the areas of light and those of shade. The areas treated with color are done with a delicate but visible line, that darkens and lightens as needed. The cheerful timbre of the wallpaper, which complements the girl's mahogany-colored hair, lends a pleasant compositional nimbleness to the pastel.

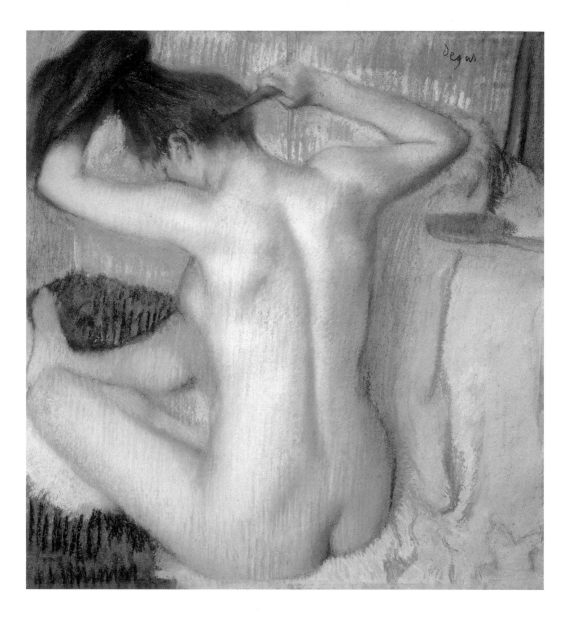

Portrait of Mary Cassatt

c. 1884
Oil on canvas, 71.4 × 58.7 cm
Washington, D.C., National
Portrait Gallery, Smithsonian
Institution

Mary Cassatt, an American painter, sat on several occasions for her friend Degas, posing for some versions of the *Milliner's*, and some portraits like this one, now in Washington, D.C., done sometime around 1884.

In portraiture, the link between Manet and Degas is very close. The use of blacks and whites, the poses, the interest in the setting, the pursuit of naturalness and spontaneity are all elements they shared. However, though they had these points in common, the two painters were dissimilar in temperament, and they each had a different way of making the human figure come alive in a portrait. It is complicated and perhaps not appropriate to attempt to explain in words a difference that has to do with visual qualities, but once again it is Valéry who can come to our aid in articulating this thought. About the portrait of Berthe Morisot by Manet, the critic writes: "That face with the big eyes, the vague stare of which gives a feeling of deep distraction, and offers, in some way, *a presence of absence*—the combination of all this fills me with a unique sensation… of *poetry*." I believe that Degas lacks what Valéry means by "poetry," that is, a sort of enchantment felt by the painter before the subject, which Degas's analytical intellect at times impeded.

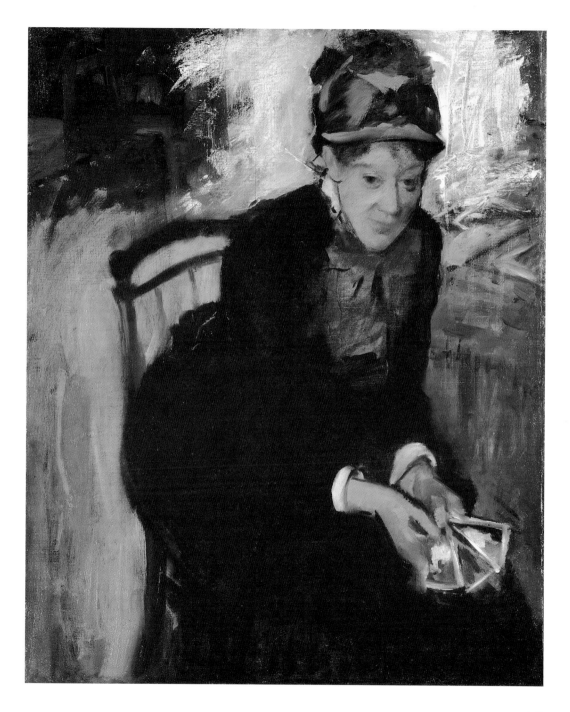

Women Ironing
(Les repasseuses)

c. 1884
Oil on canvas, 76 × 81.5 cm
Paris, Musée d'Orsay

Degas's oeuvre overall is distinguished by the apparently banal gestures that he decided to use in portraying his female subjects, captured while they do everyday chores. His attitude of a voyeur observing the common people and their toil and drudgery as they struggle to make a living never assumes a polemical aim regarding the difficult conditions in which the less advantaged classes find themselves.

There are many similarities between the work of Degas, who effectively recorded work postures, and that of Émile Zola, who wrote the *Rougon-Macquart* novels. In the first book of the series, *Le ventre de Paris* (The Fat and the Thin), the novel unfolds on various levels, one overall and the others individual ones concerning the characters. The style is that of a detailed dossier. The tone is constructed around a sort of parody. The narrator stays outside of the events and observes and takes notes like a voyeur-director who shuffles and coordinates the levels of the plot. Degas's series of pastels, if considered altogether, make up a visual novel of Paris in those years that could act as a pendant to Zola's work.

The women ironing become, if observed in this perspective, two of the many characters in the album of Paris that Degas put together. The woman on the right works hard, curved over her iron, which she moves applying all the weight of her own figure. The other grasps a bottle of wine and yawns, raising her hand to her cheek. No other components are brought into the scene, which illustrates itself effectively with just a few elements.

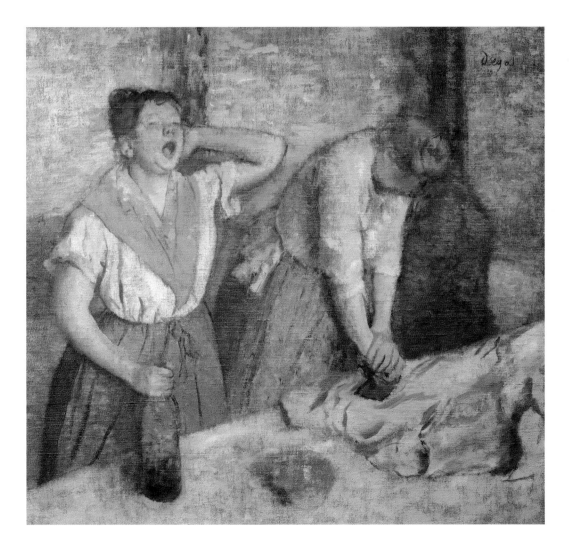

The Milliner's Shop

c. 1885
Pastel, 100 × 111 cm
Chicago, The Art Institute
of Chicago

Sometimes Degas was fascinated by feminine charm, even if he never raised it to the ultimate aim of his paintings. It is typical to find in the painting of the second half of the nineteenth century artists who, with an adulating manner, made a name for themselves among society ladies because they knew how to use the exquisiteness of their art to conceal the imperfections of the face or figure. Degas's women are not beautiful because they are charming creatures, but because the interpretation of their movements and poses is truly masterful. Valéry maintained that there was even a touch of misogyny in the artist's natural disposition.

In *The Milliner's Shop*, a young woman examines a hat that she holds out in front of her. To construct the picture, Degas cropped his composition in a way that, looking closely, is very unusual, but done so perfectly as to seem almost natural. The original perspectives in his pictures were, instead, the fruit of lengthy meditation and reconsideration. In Ernest Rouart's memoirs we read: "Degas was satisfied with himself only with difficulty, and rarely did he feel that a work was alright. [...] For him to be satisfied, it was necessary for his work to be complete not in the perfection of the details, but in the overall impression that it had to give; in the first place, in the construction and in the coordination of the various elements that made it up, that is, in the right relationships between the lines of the drawing, the values and the colors between them. He attributed great importance to the composition, to the overall arabesque of the lines, then to the rendering of the form and the modeling—the accent of the drawing, as he said. He never found that he had gone too far in the vigorous expression of the form."

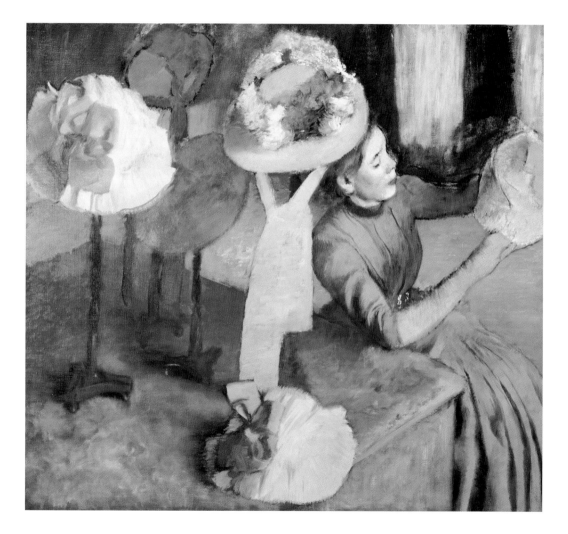

The Tub

1886
Pastel, 60 × 83 cm
Paris, Musée d'Orsay

At the last impressionist exhibition in 1886, Degas presented a series of ten pastels depicting women bathing, drying themselves, combing their hair. His female nudes have the prosaic truth of the gestures they are making, daily rites in which nothing survives of the marble ideal that had been chosen by the artists connected with the academic tradition. In the history of art, the nude had always been considered a form to idealize, so that it would be worthy of representation without a component of obscenity emerging. Degas avoided obscenity through the representation of gestures that have no hint of the voluptuous, because they fall under the class of natural tasks that our physical being imposes on us. The faces are almost always hidden by the positions taken by the models, making it clear that it is the figure itself that is to be observed. Paul Valéry remarked on the subject, observing, "For all his life, Degas sought in the nude—examining it from all sides, in an incredible number of poses, and even in full activity—the unique system of lines that *expresses* a figure at a given moment with the greatest precision, but also with the greatest generalization possible."

The pastel *The Tub* shows a woman crouched with her back to us, in the act of sponging her neck. The ledge to the right in the foreground intrudes in the scene, staggering the space to make possible a perception of depth in the setting described.

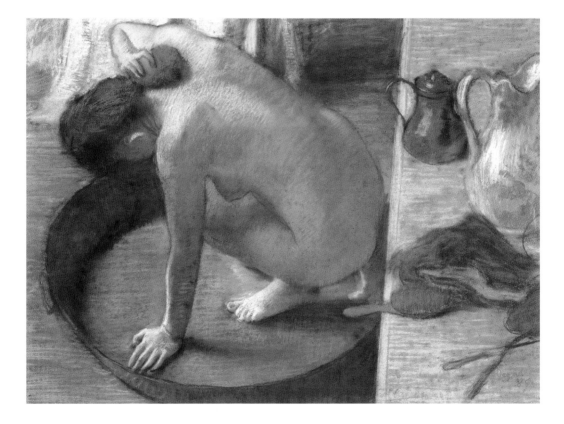

Woman Drying Her Feet

1886
Pastel, 54.3 × 52.4 cm
Paris, Musée d'Orsay

We read in Degas's notes: "[…] the human beast that has taken care of itself, a cat that is licking itself. Until now, the nude has always been presented in poses that presumed a public; instead, my women are simple, honest people, who are just seeing to their personal care. Here is another, she is washing her feet, and it is as if she were being watched through the keyhole." In Valéry's memoirs, the artist is recalled as a misanthrope, an attitude that is confessed in a veiled way in these notes. To see and observe the human being with the detachment of an anatomist or a zoologist is not, in any case, such a rare attitude in the entire context of the history of art. There certainly is nothing sentimental in the way the Renaissance artists made their "flayed" nudes, which Degas surely knew. It is also true, however, that those were anatomy studies, and these by Degas are, instead, female portraits. His contemporaries had noticed the element of assiduous analysis present in the artist's work, and most of them did not like it at all.

In the act of bending over to reach the lower extremity of her body, the young model shown in the pastel *Woman Drying Her Feet* assumes an awkward pose. Her hair falls untidily over her legs, and the red locks have as their backdrop the lemon yellow of the armchair in the back of the room. A piece of doorjamb or wall opens onto the scene, creating a real sensation of viewing the subject from a hidden vantage point.

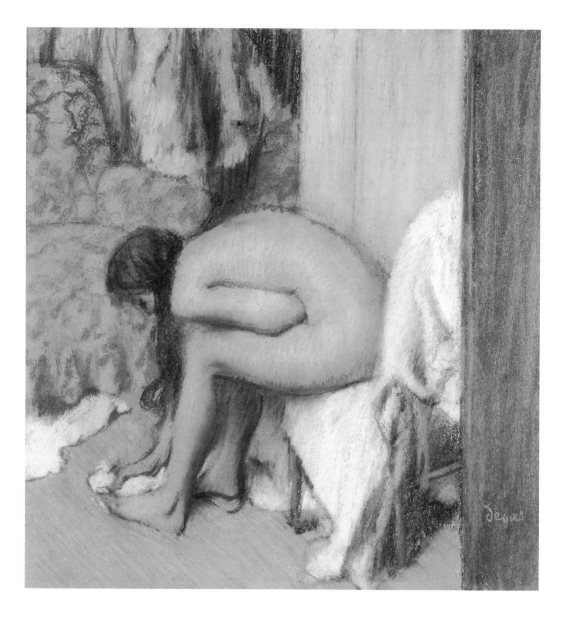

Landscape by the Edge of the Sea

c. 1892
Oil paint monotype and pastel
on paper, 27 × 36 cm
Neuchâtel, Musée d'Art
et d'Histoire

In the vast body of Edgar Degas's works, landscape painting remains the genre the artist turned to least frequently. He had done a series of views at the end of the 1860s and returned to the subject after more than twenty years with a series of landscapes he did in the fall of 1892, displayed at the Durand-Ruel gallery on the occasion of a solo exhibition. The landscape published here is one from this second series, that Italian painter Giovanni Boldini noticed when he visited the show. In a letter to Telemaco Signorini, Boldini describes the positive impression he got from the paintings Degas had on view, all "of capital interest."

Boldini had met Degas for the first time in Paris at the start of the 1870s, and had understood right then the importance of his experiments. Degas suggested to him points of view with multiple perspectives that Boldini interpreted and developed in a dynamic way by means of a brushstroke that tends to get longer and longer from painting to painting, becoming a sort of painterly calligraphy. The landscape genre, toward the close of the century, represented a real opportunity to make a lyrical interpretation of nature, to express the feeling that man gets when in the presence of nature's spectacle. This approach also confirms that the realist method of representing reality was by now considered by most to be insufficient. Therefore, among the choices taken by contemporary artists, there appeared an approach reassessing the poetics of the fantastic and the oneiric, one that inspired the *fin-de-siècle* symbolists, for whom the landscape was one of the main genres adopted for expressing this change of heart.

Combing the Hair
(La Coiffure)

c. 1896

Oil on canvas, 114 × 146 cm
London, National Gallery

Degas did many studies of women behind closed doors making the gestures connected with their personal care. To reveal the female figure, he made use of drawing. His pastels, like his oil paintings, are color and drawing.

Ever since his youth, Degas had loved the painting of Ingres. He often repeated out loud the great master's teaching, but he never talked about his own ideas on art. "Degas liked to talk about painting," recalls Paul Valéry, "but he could not bear that others talked about it. Even less so, if those talking were intellectuals. […] I said to him: 'But, in essence, what do you mean by *design*?' He answered with his famous axiom: 'Drawing is not form, it is the way of seeing form.' And here the storm broke. […] I could guess, though, what he meant to say. He distinguished between what he called the 'design,' that is the exact representation of the object, and what he called the 'drawing,' that is the specific changes that an artist's way of seeing and of working operate on the exact representation."

It was through drawing that Degas changed the forms in the late works. The black line that at points defines the contours in this canvas does not exist in realty. The outline is an element that the eye imagines it sees in order to record reality. The drawing is understood as a means for recording and as the objective of seeing. "There is an immense difference between seeing a thing without a pencil in hand, and seeing it while *drawing* it": once again, it is Valéry making the observation, when he explains with regard to Degas's approach, the way of perceiving the world through the selective process that painting imposes. The writer's examination is a personal interpretation of Degas's work, a point that he stresses several times. The artist's role is to communicate through his art; that of the theoretician is to infer the meanings, which still remain debatable opinions.

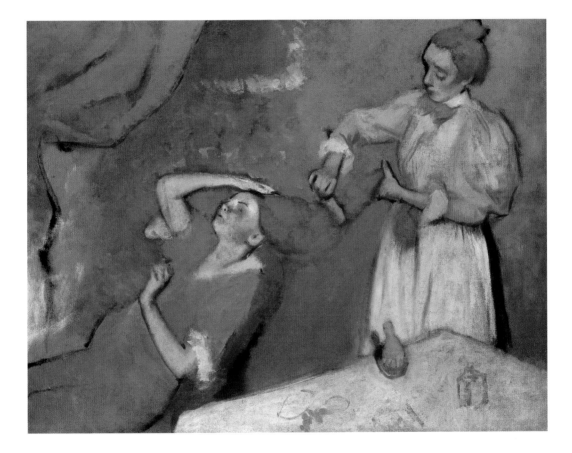

Woman Drying Her Neck

1895–1898
Pastel, 62.5 × 65 cm
Paris, Musée d'Orsay

The pastel *Woman Drying Her Neck* in the Musée d'Orsay shows a young woman who, drying herself after her bath, has got herself in a position that, if considered according to traditional aesthetic canons at the time, could have seemed disharmonic, and therefore not suited for the posing of a nude.

Huysmans, art critic and writer, penned one of the finest commentaries about the work of Degas, entitled *Certains*: "Degas, who in splendid pictures of dancers had already so implacably rendered the decadence of the mercenary with her mechanical clowning comedy and monotonous leaps, cultivated [...] with his studies of nudes, a meticulous cruelty, a patient hatred. It seemed as if he sought his revenge, tossing the most excessive outrage in the face of his century by demolishing that ever-spared idol, woman, whom he degrades. [...] But apart from this particular accent of disdain and aversion, we must see in those works the unforgettable authenticity of the models, executed with a sweeping and far-reaching hand [...]; we must see the color, bright or muted, the mysterious, opulent tone of those scenes; it is the supreme beauty of the flesh made bluish or pinkish by the water, brightened by closed windows with muslin curtains, in dim rooms where one can see, in the diffused light of courtyards, walls hung with Jouy fabric, sinks and basins, phials and combs, polished boxwood brushes, pink copper foot-warmers!" Huysmans grasps the dual value of Degas's pastels: on the one hand, there is an unforgiving eye that bares the wretchedness of the human figure; and on the other, the refined touch of the genius artist, that glorifies the wretched flesh with the beauty of interpretation.

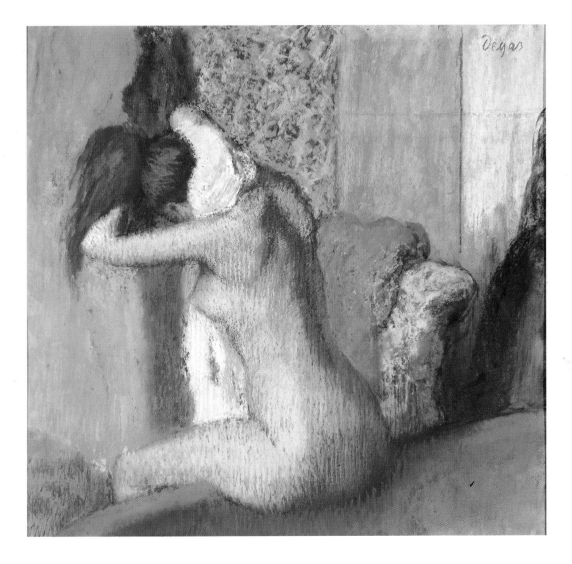

163

Blue Dancers

c. 1897
Pastel, 67 × 67 cm
Moscow, The Pushkin State
Museum of Fine Arts

From the mid-1870s, Degas used his pastels with increasing frequency, to the point that critic Philippe Burty declared that the artist had abandoned oil painting in favor of a "painting with glue and pastels." This technique gradually helped him improve his already natural drawing talent. It was a challenge that Degas made to painting, through his drawing, a medium for which he had felt an affinity since his youth, when he followed Ingres's examples. Now, the drawing is no longer the padding for the painting, but, instead, it is transformed into color, becoming the cornerstone of his painting. At times, he uses the pastel to outline, at others to color, and yet others, he breaks it up into hatching, or into a vaporous cloud of color. The backdrops become increasing complementary to the definition of the subjects. The paintings are conceived in zones, all of which are equally important whether they contain the nude, subject of the picture, or represent a drape, a piece of furniture, a screen, or simply something that is not defined: a smudge that has a value inasmuch as it has a certain "chromatic weight" within the perfect, algebraic arrangement of the space.

In *Blue Dancers*, Degas shows a sublime elegance of composition. The act of the dancers straightening up their costumes is interpreted as a dance, with a swirl of arms, faces and shoulders, put together with consummate grace recalling the extraordinary charcoal drawings of the modern masters, the images of which had always remained indelibly in Degas's mind, and remained there throughout the years of old age.

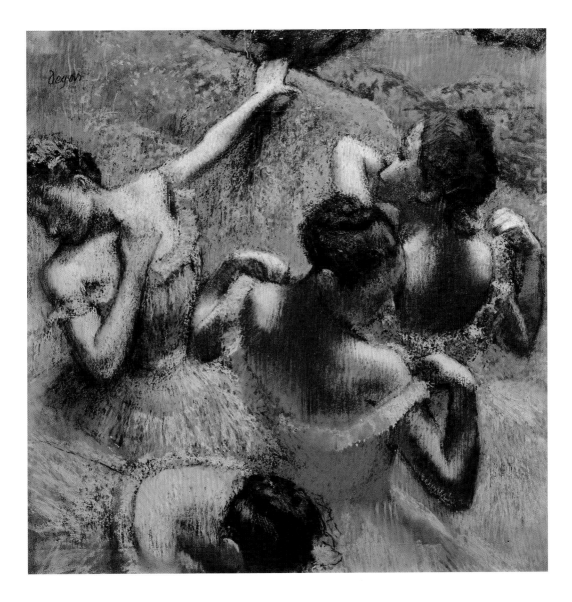

165

Dancers at the Barre

c. 1900
Oil on canvas, 130 × 96.5 cm
Washington, D.C.,
The Phillips Collection

The dating of this work is controversial. Some scholars include it in the output of the 1880s. However, the extreme simplification of the forms suggests that it could be later. The drawing is made with a few fragmented lines that at some points outline the form. The color fills the figures by flat color zone. In some parts, for example, in the lower limbs, form and color take on a purely evocative value. The legs are orange and green, just as the floor and the costumes are, from which they absorb and reflect chromatic tones. Degas maintained that the drawing is not form, but it is the "way" of seeing form. Paul Valéry explains that the painter makes a distinction between what he calls the "design," that is, the exact representation of the object, and what he called the 'drawing,' that is, the specific changes that an artist's way of seeing and of working operate on the exact representation," which is what one would get from the use of photography. The realization of these two *Dancers at the Barre* is a far cry from a photographic image, which would show, according to Valéry's reasoning, the "exact representation." Degas's image is, instead, a sort of "personal error" that the painter made intentionally to interpret reality, in producing his interpretation of the observable world.

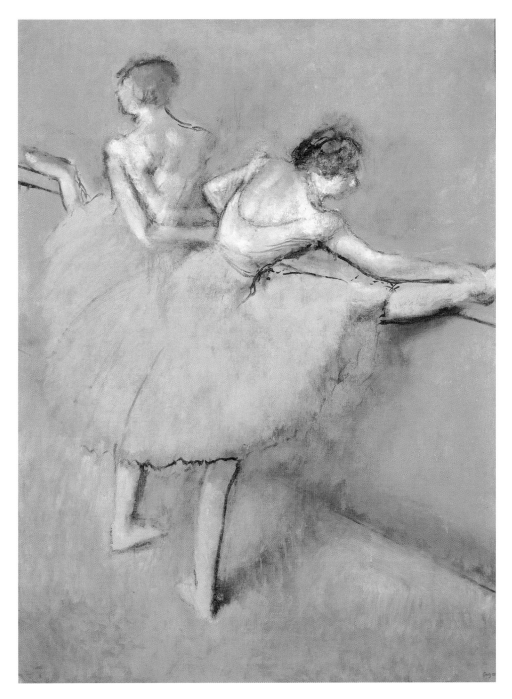

167

Three Dancers

c. 1900
Pastel
Belgrade, Narodni Muzej

In this final phase, space and color are handled in a way that seems at odds with reality, with the scope of creating relationships within the work that, at this point, no longer have anything to do with some presumed objective sight. The path that Degas took was common to many impressionists. Cézanne, first among all, by reducing natural forms to elementary geometric forms, interpreted Impressionism as a highly personal moment of grappling with reality. Monet, in his _Water Lilies_, achieved results that border on the abstract. Degas ended up reducing anatomical forms to semblances, in favor of the color that invades the picture as imperious as an absolute master. Flat color zones and lines are used, at some points, to contain and define whatever survived of the clean and harmonious contours that Degas had learned in his youth from Ingres.

The mannequin-ballerinas of the late period seem to anticipate the experiments soon to be made by the Dada artists, or, in the German milieu, members of the Bauhaus.

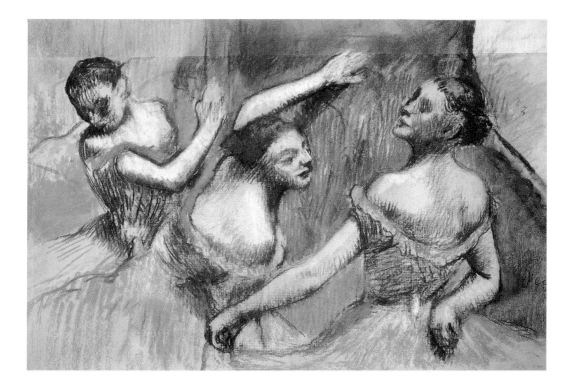

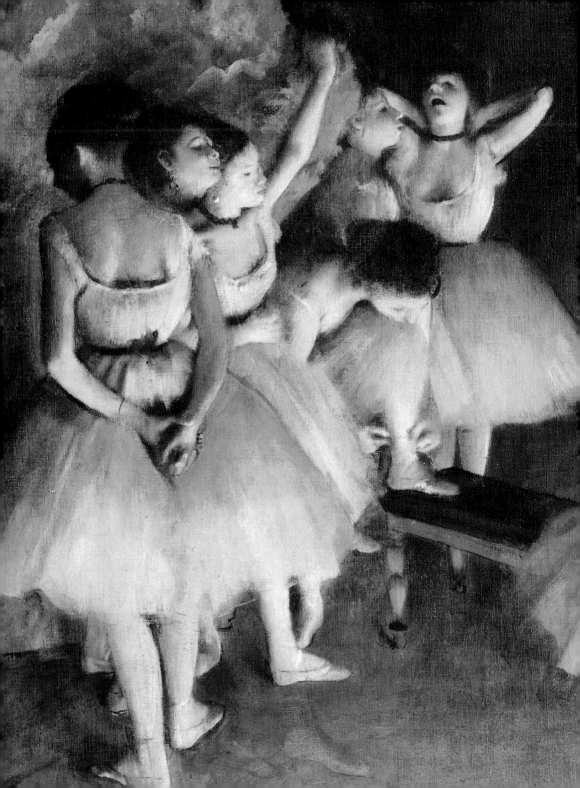

Appendix

Ballet Rehearsal on the Stage
(detail), 1874
Paris, Musée d'Orsay

Chronological Table

	Life of Degas	Historical and Artistic Events
1834	Hilaire-Germain-Edgar Degas is born in Paris on July 19. His father, Laurent-Pierre-Auguste de Gas, is a banker; his mother, Célestine Musson, is from New Orleans.	In his lithograph *Rue Transnonain*, Daumier illustrates the massacre in a working class district of Paris, when government troops under Louis Philippe opened fire on the inhabitants of a building.
1845	He enrolls at the Lycée Louis-le-Grand in Paris. With his father, an art and music lover, a man of culture, he visits the Louvre and gets to know some Paris collectors, including Valpinçon, the owner of Ingres's *Bather*.	
1852	In Rue Mondovi, he establishes a studio in his father's apartment.	Louis Napoleon proclaims himself emperor. Tsar Nicholas I opens the Hermitage Museum to the public.
1853	After receiving his Baccalaureate in law, he enters the studio of Barrias. At the Louvre and the Cabinet des Estampes at the Bibliothèque National, he copies the works of Dürer, Mantegna, Rembrandt, and Goya.	Crimean War (ended in 1856).
1854	Becomes a pupil of Lamothe, a disciple of Ingres. Starts a series of study trips to Italy.	French expansion in Senegal and founding of Dakar. Thanks to the reopening of Japan's borders to foreign trade (closed since 1638), Japanese prints appear on the western market.
1855	Gains admission to the École des Beaux-Arts. Thanks to Valpinçon, he meets Ingres.	The Paris Exposition Universelle holds a retrospective exhibition dedicated to Ingres.
1856	After a stay in Rome, he moves to Naples, where he starts to paint the two portraits of the Bellelli cousins. Back in Rome, he copies the ancient art.	In Florence Prince Demidoff opens his collection to the public; it is rich in works by such French artists as Ingres, Delacroix, Corot, the Barbizon school painters and others.
1857	In Rome, attending the Académie Française, he meets Gustave Moreau.	French expansion in Algeria, with the taking of the Kabylia.
1858	Returns to Rome in the spring, after a winter in Paris; in July he travels to Florence, visiting en route Viterbo, Orvieto, Perugia, and Assisi. In the Tuscan city he meets up again with his friend Moreau, and spends time with the Macchiaioli at the Caffè Michelangelo. Some studies for *The Bellelli Family* date from this period.	Anglo-French expedition to China.

Life of Degas	Historical and Artistic Events
1860 During his stay with Paul Valpinçon at Mesnil-Hubert, he discovers a fascination for horses and the racing greens.	The Expedition of the Thousand in Italy. With the Treaty of Turin, Cavour cedes Nice and Savoy to France.
1862 Meets and makes friends with Édouard Manet.	Abolition of slavery in the United States. Cézanne quits his job in a bank and dedicates himself to painting. Fattori's painting *Field After the Battle of Magenta* wins a prize in Florence, the first recognition for the Macchiaioli.
1865 Receives compliments from Puvis de Chavannes for a pastel shown at the Salon.	Manet's *Olympia*, shown at the Salon, rouses much debate.
1866 Starts to spend time at the Café Guerbois. Shows pictures with scenes of horse races at the Salon.	Seven Weeks' War: Prussian-Italian alliance against Austria.
1870 Enrolls in the infantry with the outbreak of the Franco-Prussian War. At the Salon, shows the portrait *Madame Camus in Red with Fan*.	Outbreak of the Franco-Prussian War on July 18. The Third Republic is proclaimed. French troops are defeated at Sedan. Rome is annexed to the Kingdom of Italy.
1872 Attends the ballet at the Opéra. In October leaves for New Orleans with his brother René.	Manet signs with Jongkind, Pissarro, Cézanne, Renoir and others for a new Salon des Refusés.
1873 Back in Paris, he spends time once again with the impressionist group.	Napoleon III dies. Rimbaud publishes *Une saison en enfer*, Nietzsche, *The Birth of Tragedy*.
1874 Takes part in the first impressionist exhibition, where he displays ten works between oils, drawings, and pastels.	Monet shows *Impression: soleil levant* at Nadar's studio.
1875 Starts painting *Glass of Absinthe*.	On March 24 the impressionists organize an auction at the Hôtel Drouot.
1876 The second impressionist exhibition is inaugurated at the Durand-Ruel gallery, and Degas is present with twenty-four works. Duranty publishes his pamphlet *La Nouvelle Peinture – À propos du Groupe d'artistes qui expose dans les Galeries Durand-Ruel,* inspired by Degas's theories about the "new painting."	Rivière writes a first article on the impressionists. Mallarmé publishes *L'après-midi d'un faune* illustrated by Manet.

	Life of Degas	Historical and Artistic Events
1877	At the group's third show, participates with twenty-seven paintings of different genres, depicting ballet dancers, café-concerts, and female nudes.	The Neapolitan sculptor Gemito gains extraordinary success showing his bronze of the *Pescatorello* (*Neapolitan Fisherboy*) at the Paris Salon. Moreau is present at the same Salon with his *Salomè*.
1878		Paris Exposition Universelle. Durand-Ruel exhibits several works of the Barbizon painters. Duret publishes his *Les impressionnistes*.
1879	Takes part in the fourth impressionist exhibition.	Redon publishes his first album of lithographs, entitled *Dans le rêve*.
1880	Dedicates himself to engraving, together with Mary Cassatt and Pissarro. Shows ten or so works at the fifth impressionist exhibition.	Tahiti becomes a French colony. Dostoevsky publishes *The Brothers Karamazov*. Deaths of Flaubert, Eliot, and Offenbach.
1881	Some of his pastels and statuettes, including a wax sculpture entitled *Little Dancer Aged Fourteen*, are shown at the sixth impressionist exhibition.	First solo exhibition of drawings by Redon in the gallery of the journal *La Vie Moderne*. Taine publishes his *Philosophy of Art*. Picasso is born in Malaga.
1882	Depicts women ironing and milliners. Does not take part in the seventh Impressionist exhibition.	The Triple Alliance was signed by Italy, Germany and Austria. Courbet has a retrospective at the École des Beaux-Arts.
1883	On April 30, his friend Monet dies. He withdraws into profound isolation.	Durand-Ruel shows works by the impressionists in London, Berlin, Rotterdam, and Boston.
1885	Admires the work of Paul Gauguin. His sight problems, which had emerged a few years earlier, worsen.	Delacroix has a retrospective at the École des Beaux-Arts. Dujardin founds the Revue Wagnérienne.
1886	Participates in the last (the eighth) impressionist exhibition with pastels with milliners and a series of female nudes. For Degas, the exhibition was a fiasco.	The Statue of Liberty is inaugurated in New York. The impressionists enjoy success in America. Moréas publishes his symbolist manifesto in *Le Figaro Littéraire*.
1889	Visits Spain and Morocco with the painter Boldini.	The Eiffel Tower is built for the Exposition Universelle, which hosts a show about one hundred years of French art: works of Monet, Manet, Pissarro, and Cézanne are included.

Life of Degas	Historical and Artistic Events
1890 Stays in Burgundy.	At Auvers-sur-Oise Vincent van Gogh commits suicide.
1893 His first and only solo exhibition is held at the Durand-Ruel gallery, where he displays some pastel monotypes showing Burgundy landscapes.	Vollard opens his gallery. Munich Secession.
1897 Visits the Musée Ingres at Montauban.	First show of the Vienna Secession.
1898 Now nearly blind, he dedicates himself primarily to sculpture, modeling small statues of horses in movement, ballerinas in various poses, and other subjects.	Wölfflin publishes *Classical Art*, Tolstoy, *What Is Art?* Deaths of Mallarmé, Puvis de Chavannes, and Moreau. In Vienna, O. Wagner starts his Majolika House apartments and J.M. Olbrich his Sezession building.
1900	In an Expo Universelle pavilion in Paris, a show of Rodin's sculptures is organized. In Vienna, Freud publishes *The Interpretation of Dreams*.
1903	The Die Brücke group is formed in Dresden. Deaths of Gauguin, Pissarro, and Whistler.
1905 Paints *Madame Rouart and Her Two Children*.	Einstein's Theory of Relativity.
1906	Henri Bergson publishes *Creative Evolution*. Cézanne dies.
1907	Picasso paints *Les Demoiselles d'Avignon*.
1909	First Futurist manifesto.
1912 Leaves his address in Rue Victor Massé, which had been his home and studio for nearly twenty years, and moves to Boulevard de Clichy.	All over Europe, several shows of cubist artists are organized. In Paris, A. Gleizes and J. Metzinger publish *On Cubism*. Picasso makes his *Guitar*, the first Cubist sculpture.
1914	World War I. Kokoschka paints *The Bride of the Wind*.
1917 Edgar Degas dies on September 27 and is buried in the Montmartre cemetery.	Russian Revolution. Italian defeat at Caporetto. Rodin dies. In Leyden, Van Doesburg founds the review *De Stijl*.

Geographical Locations of the Paintings

France

Portrait of the Painter
Bonnat
Oil on canvas, 43 x 36 cm
Bayonne, Musée Bonnat
c. 1863

Café-Concert aux
Ambassadeurs
Pastel, 37 x 27 cm
Lyon, Musée des Beaux-Arts
1877

Self-portrait
Oil on canvas, 81 x 64.5 cm
Paris, Musée d'Orsay
1854–1855

The Bellelli Family
Oil on canvas, 200 x 250 cm
Paris, Musée d'Orsay
1858–1867

Semiramis Founding Babylon
Oil on canvas, 151 x 258 cm
Paris, Musée d'Orsay
1860–1862

The Parade
(Race Horses in front
of the Tribunes)
Oil on canvas, 46 x 81 cm
Paris, Musée d'Orsay
1866–1868

Portrait of a Young Woman
Oil on canvas, 27 x 22 cm
Paris, Musée d'Orsay
1867

The Orchestra at the Opéra
Oil on canvas, 56.5 x 46 cm
Paris, Musée d'Orsay
c. 1868

Houses by the Seaside
Pastel, 31.4 x 46.5 cm
Paris, Musée du Louvre,
Cabinet des Dessins
1869

Lorenzo Pagans and
Auguste de Gas
Oil on canvas, 54.5 x 40 cm
Paris, Musée d'Orsay
c. 1869

France

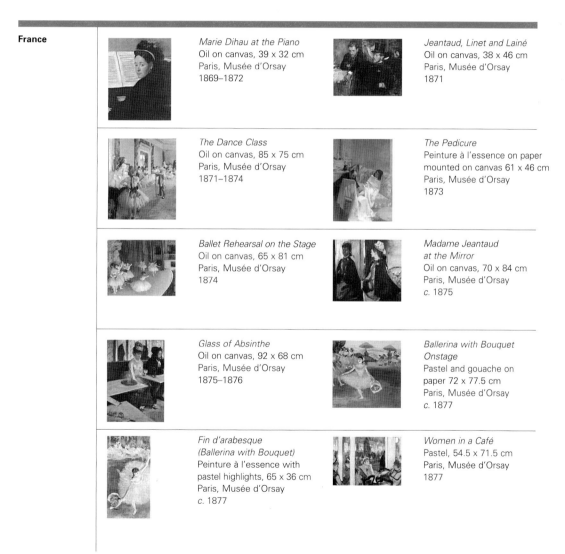

Marie Dihau at the Piano
Oil on canvas, 39 x 32 cm
Paris, Musée d'Orsay
1869–1872

Jeantaud, Linet and Lainé
Oil on canvas, 38 x 46 cm
Paris, Musée d'Orsay
1871

The Dance Class
Oil on canvas, 85 x 75 cm
Paris, Musée d'Orsay
1871–1874

The Pedicure
Peinture à l'essence on paper
mounted on canvas 61 x 46 cm
Paris, Musée d'Orsay
1873

Ballet Rehearsal on the Stage
Oil on canvas, 65 x 81 cm
Paris, Musée d'Orsay
1874

Madame Jeantaud
at the Mirror
Oil on canvas, 70 x 84 cm
Paris, Musée d'Orsay
c. 1875

Glass of Absinthe
Oil on canvas, 92 x 68 cm
Paris, Musée d'Orsay
1875–1876

Ballerina with Bouquet
Onstage
Pastel and gouache on
paper 72 x 77.5 cm
Paris, Musée d'Orsay
c. 1877

Fin d'arabesque
(Ballerina with Bouquet)
Peinture à l'essence with
pastel highlights, 65 x 36 cm
Paris, Musée d'Orsay
c. 1877

Women in a Café
Pastel, 54.5 x 71.5 cm
Paris, Musée d'Orsay
1877

France	

Carriage at the Races
Oil on canvas, 66 x 81 cm
Paris, Musée d'Orsay
1877–1880

*The Painter's Friends
in the Wings*
Pastel and tempera on
paper, 79 x 55 cm
Paris, Musée d'Orsay
c. 1879

Woman Bathing
Pastel (or pastel over
monotype), 19 x 41 cm
Paris, Musée d'Orsay
c. 1883

*Women Ironing
(Les repasseuses)*
Oil on canvas, 76 x 81.5 cm
Paris, Musée d'Orsay
c. 1884

The Tub
Pastel, 60 x 83 cm
Paris, Musée d'Orsay
1886

Woman Drying Her Feet
Pastel, 54.3 x 52.4 cm
Paris, Musée d'Orsay
1886

Woman Drying Her Neck
Pastel, 62.5 x 65 cm
Paris, Musée d'Orsay
1895–1898

*A Cotton Exchange
in New Orleans
(Portraits in an Office)*
Oil on canvas, 74 x 92 cm
Pau, Musée des Beaux-Arts
1873

Germany

The Orchestra Musicians
Oil on canvas, 69 x 49 cm
Frankfurt, Städelsches
Kunstinstitut und Städtische
Galerie
1874–1876

Japan		*Édouard Manet and His Wife* Oil on canvas, 65 x 71 cm Kitakyushu, Municipal Museum of Art 1868–1869		
Great Britain		*Portrait of Diego Martelli* Oil on canvas, 110 x 100 cm Edinburgh, National Gallery of Scotland 1879		*Young Spartans* Oil on canvas, 109 x 154.5 cm London, National Gallery 1860–1862
		Miss La La at the Cirque Fernando Oil on canvas, 117 x 77.5 cm London, National Gallery 1879		*Combing the Hair* *(La Coiffure)* Oil on canvas, 114 x 146 cm London, National Gallery 1892–1895
Russia		*Ballerina Posing for the Photographer* Oil on canvas, 65 x 50 cm Moscow, The Pushkin State Museum of Fine Arts c. 1875		*Blue Dancers* Pastel, 67 x 67 cm Moscow, The Pushkin State Museum of Fine Arts c. 1897
		After the Bath Pastel, 50 x 50 cm St. Petersburg, The State Hermitage Museum 1884		

Serbia		*Three Dancers* Pastel Belgrade, Narodni Muzej *c.* 1900		
Switzerland		*Landscape by the Edge of the Sea* Oil paint monotype and pastel on paper, 27 x 36 cm Neuchâtel, Musée d'Art et d'Histoire *c.* 1892		
United States		*At the Races in the Countryside* Oil on canvas, 36.5 x 55.9 cm Boston, Museum of Fine Arts 1869		*The Milliner's Shop* Pastel, 100 x 111 cm Chicago, The Art Institute of Chicago *c.* 1885
		Ballerinas Pastel, 64.8 x 50.8 cm Dallas, Museum of Art 1883		*A Woman Seated Beside a Vase of Flowers (Madame Paul Valpinçon)* Oil on canvas, 74 x 93 cm New York, The Metropolitan Museum of Art 1865
		James Tissot Oil on canvas, 151.5 x 112 cm New York, The Metropolitan Museum of Art *c.* 1867-1868		*Portrait of Mademoiselle E. F... in the Ballet "La Source"* Oil on canvas, 130 x 145 cm New York, Brooklyn Museum of Art 1867–1868

United States

*At the Milliner's
(Mary Cassatt)*
Pastel, 67 5 67 cm
New York, The Museum
of Modern Art. Gift of Mrs.
David M. Levy.
Digital Image © 2002
Florence, The Museum of
Modern Art, New York/Scala
c. 1882

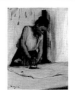

*Woman Ironing
(La repasseuse)*
Oil on canvas, 25 x 19 cm
Pasadena, Norton Simon
Museum
1875

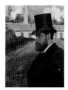

*Henri Rouart in front
of His Factory*
Oil on canvas, 65.6 x 50.5 cm
Pittsburgh, Carnegie Museum
of Art
c. 1875

Portrait of Mary Cassatt
Oil on canvas, 71.4 x 58.7 cm
Washington, D.C., National
Portrait Gallery, Smithsonian
Institution
c. 1884

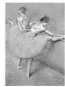

Dancers at the Barre
Oil on canvas, 130 x 96.5 cm
Washington, D.C., The Phillips
Collection
c. 1900

181

Writings

Excerpts from Degas: An Intimate Portrait
by Ambroise Vollard

EARLY ENCOUNTERS WITH DEGAS
[…] I found Degas putting a portrait of a woman, which seemed unusually finished, back into a folio.

"I'll have to touch it up a little," he remarked as I came in.

"I am sure Monsieur L. ought to be very grateful to you," I said.

He sighed. "Yes—How pleasant it would be to give people things if you only didn't have to listen to their thanks."

Just then a delivery boy entered, carrying a basket full of toys.

"My friend J.'s children are coming over day after to-morrow to wish me a Happy New Year," Degas explained. "I've got to be prepared, you know. I've been rummaging around in Place Blanche, and this is my first haul. Isn't that a magnificent soldier? And what do you think of the doll? The elephant is for me. They assured me it was real skin. It was the trunk that tickled me most; see how it lifts up when I pull the string?"

I had come to invite Degas to dinner that evening. "Certainly, Vollard," he said. "But listen: will you have a special dish without butter prepared for me? Mind you, no flowers on the table, and you must have dinner at half past seven sharp. I know you won't have your cat around and please don't allow anybody to bring a dog. And if there are to be any women I hope they won't come reeking of perfume. How horrible all those odors are when there are so many things that really smell good, like toast—or even manure! Ah—" he hesitated, "and very few lights. My eyes, you know, my poor eyes!"

Degas used to pretend to be more blind than he was in order not to recognize people he wanted to avoid. But one day he ran into an acquaintance of thirty years' standing and asked him his name, adding, "It's my poor eyes, you know." Then he forgot he could not see and pulled out his watch. […]

Degas' studio was always in a state of confusion. He would not permit the least thing to be

touched, in consequence the room was a clutter of all sorts of objects, from painting materials to piles of magazines and pamphlets.

One day when I came to see him I happened to be carrying a package under my arm. A tiny piece of paper, no larger than a bit of confetti, worked loose from the wrapping and fell on the floor. Degas pounced on it, dug it out of the crack where it had lodged, and threw it into the stove. "I don't like disorder," he said.

But Degas did not wish to "see" he was very anxious to hear, in spite of the fact that he was somewhat hard of hearing. He always insisted that people talked indistinctly or badly, and a whole evening spent carefully articulating each word was as good as wasted if one happened to say *au revoir* a little more hastily than usual.

Degas was much beset by bores, and if he found he could not reasonably escape them by his favorite excuse of not seeing—as when he was invited to hear Madame X.'s beautiful singing— he would say, "It makes me dizzy."

One day when Renoir was telling me how he was victimized by all sorts of people, I said: "Why don't you do what Degas does: tell them it makes you dizzy?"

"Yes," replied Renoir, "but do you think they will let you off as easily as that?" He glanced down at his feet, which had long since refused to serve him, and muttered, "Degas has his legs, at least."

There is no doubt but that Degas was a good deal of an eccentric, and his whims and odd retorts naturally only increased this reputation. Yet, even so, people were too easily inclined to judge him unfairly because he resented being imposed on and dragged about to exhibitions of paintings or nine o'clock dinners and made to sit at a table which looked like a florist's window, simply because it was the thing to do.

ZOÉ

From time to time Degas would invite a friend to dinner. "You shall have some of Zoé's orange marmalade," he would promise, as if to make a special occasion of the evening. And Zoé, who was not in the least unaware of how much her preserves were appreciated, would take advantage of the situation. The first time I went to see Degas he was at lunch, usually the best hour to find him in.

"Zoé," the painter called out sharply; "I am having company for dinner this evening."

"No, monsieur; you will have to take your friend to a restaurant. I don't want you around this evening."

Degas' expression had grown very severe. What with his reputation for being a hot-tempered man, I fully expected he would get up and strike Zoé. But she went on serenely:

"I am making jam today, and I don't want to be disturbed."

"Very well," was all Degas said, and after Zoé had gone back to the kitchen I remarked:

"Did you know, Monsieur Degas, that most people think you very hot-tempered?"

"I don't wish to be good-hearted," he said.

Meanwhile Zoé had brought in the salad. Degas always dressed it himself, for the exact amount of oil required was almost a rite with him. He reached for the oil cruet and found it empty.

"Haven't you any oil?" inquired Degas.

"I'll go get some, monsieur. There's a shop next door."

Zoé returned a quarter of an hour later. "Well, where's the oil?" asked Degas impatiently.

Zoé was flustered. "I'll go right back, monsieur," she apologized. "I made a mistake and got vinegar."

Degas managed to remain calm, and when the servant had gone out again, he sighed, "Poor Zoé!"

"Whom did you have before Zoé?" I inquired.

"Sabine was with me before Zoé. She made good orange marmalade too."

Degas told Sabine one evening that some friends were coming in and that she had better make something for them to drink. Sabine therefore prepared another drink in addition to the

customary camomile for her master. "What is this concoction you are giving us, Sabine?" one of the guests inquired.

"Do you like it?" she asked eagerly. "The master told me I must get something good, so I bought some licorice at the corner and warmed it up with a little sugar."

Degas' soirées were of course somewhat different from the one the Baroness of Cl. T. gave in his honor. When the evening was over, a valet called for the attendants of the Prince of W., the English ambassador, and other gentry.

"But," exclaimed a lady who did not know just how important a personage Degas might be, "what about Monsieur Degas' attendants?"

"Monsieur Degas' attendants are Zoé," replied the painter, "and she has been asleep in bed since eight o'clock."

IRONIES

Degas rarely ever indulged in anything more than mildly biting repartee except when art or "the established order" was attacked. Bonnat, for instance, was showing him a picture by one of his pupils, representing a warrior drawing his bow.

"Just see how well he aims!" said Bonnat.

"Aiming at a prize, isn't he?" replied Degas.

Another day an art critic, Monsieur S. and I were with Degas on the way to the Salon. "All the blue doesn't come in ink bottles, my friend," said Degas. "Some of it comes in tubes."

We had arrived at the Salon. Monsieur S. took Degas up to a portrait of a *Woman with a Corsage Bouquet*. Degas' comment was:

"Fantin-Latour has a great deal of talent, but I'll wager that he has never seen a woman with a corsage bouquet in his life."

Degas never lost an opportunity to proclaim Carrière one of the great painters. Yet that day, as he inspected the different pictures and stopped in front of the Carrières he was irritated because the art critic kept pointing them out to him, and his only comment was, "I can't see very well today."

Degas stopped to look at each canvas, and presently gave a little exclamation of disgust. "To think," he remarked, "that not one of these fellows has ever gone so far as to ask himself what art is all about!"

"Well, what *is* it all about?" countered the critic. "I have spent my whole life trying to find out. If I knew I should have done something about it long ago."

Suddenly we heard someone call "Monsieur Degas!" It was Vibert, the well-known painter of *The Cardinals*.

"You must come to see our exhibition of water-colors," he said. Then he gave a sidelong glance at the old mackintosh Degas was wearing, and added: "You may find our frames and rugs a little too fancy for you, but art is always a luxury, isn't it?"

"Yours, perhaps," retorted Degas; "but mine is an absolute necessity."

I remember a walk I took with Degas along the Grand Boulevards. Everywhere we went the sopwindows were loaded with nothing but gilded gimcracks.

DEGAS: You never used to see rubbish like that before the Dreyfus Case came up. The time will come yet when we will be ready to weep for joy at a mere display of umbrellas. Take this umbrella shop here, for example; it has a good old-fashioned French look about it. I am going in to buy a cane.

We entered, and the shopkeeper showed Degas two canes of exactly the same wood and mounting except that the handle of one of them had a leather band and loop. It was the cheaper of the two.

DEGAS (to the man): Why is the plain one more expensive? Is it in better taste than the other?

THE SHOPKEEPER: Good taste is always costly, sir. Degas went out wrapped in thought.

DEGAS: Where will it ever end? Everything is topsy-turvy nowadays. Just the other day I actually saw a little girl playing with a paint-box. The idea of giving such things to a child! […].

ANECDOTES

We were talking about the revolution of 1848. Somebody remarked to Degas that he must have been quite young at that time. Said Degas:

"I remember a story my father used to tell. As he was coming home one day, he ran across a group of men who were firing on the troops from an ambush. During the excitement a daring onlooker went up to one of the snipers who seemed to be a poor marksman. He took the man's gun and brought down a soldier, then handed it back to its owner who motioned as if to say, 'No, go on. You're a better shot than I am.' But the stranger said, 'No, I'm not interested in politics.'"

Degas always liked stories of the past. Someone was telling about the young man who was out boating with two ladies when one of them put him in an embarrassing predicament by asking: "If we were threatened with death and you were able to save only one of us, which would it be?"

Degas laughed. "I know one as good as that," he said. "Madame de Staël was in a little boat on Lake Geneva one day with Madame de Récamier and Benjamin Constant. All at once one of the rowers remarked that there was a cloud on the horizon which looked like rough weather. 'Tell me, Benjamin,' said Madame de Staël; 'if we were shipwrecked, which of us two would you save.' 'You,' Constant replied, 'because you know how to swim.'"

THE SENSITIVE ARTIST

One day when I was with Degas we ran across Monsieur Michel L., a painter whom he had known for a long time. Degas passed him by without so much as a glance. "We once exchanged pictures," he explained to me afterward, "and would you believe it, I found the one I had given him for sale in a shop. I took his own back to him the next day."

"What did he say to that? I shouldn't think that a man who can afford Watteaux would ever find himself in need of ready money."

"Oh, I didn't even ask to see him. I just left his canvas on the door-step along with the morning's milk."

Degas had once made a present of a pastel to another of his friends, the painter Z., who later sold it. Degas was offended, and afterwards when they happened to meet, he walked by without a word. But Z. ran after him and burst out with: "Really, Degas, I've had such terrible expenses— my daughter was married, you know...." "Monsieur," interrupted Degas, "I do not understand why you should tell me about your family. I really have not the pleasure of knowing you."

Degas has often been reproached for his unrelenting attitude towards people.

"If I did not treat people as I do," he would say in his own defence, "I would never have a minute to myself for work. But I am really timid by nature; I have to force myself continually...."

It may seem surprising to Degas' admirers that he thought it necessary to be violent in order to overcome his timidity. But one gets an inkling of the true character of the man in a letter to a friend, to whom he reveals the state of his soul:

"I am going to ask you to forgive me for something which keeps coming up in our conversation, and still oftener, I am sure, in your own thoughts, and that is, that throughout the course of our professional relations, I have been, or seemed to have been, 'hard' with you. I have been singularly hard with myself. I have to be. You must realize that this is so, since you have, at times, reproached me for it, and were astonished because I had so little confidence in myself. I have been, or seemed, hard with everyone because I was carried away by a sort of brutality born of my distrust in myself and my ill-humor. I have felt so badly equipped, so soft, in spite of the fact that my attitude towards art seemed to me so just. I was disgusted with everyone, and especially myself. I ask your pardon, then, if, with this damned art as an excuse, I have wounded your noble and intelligent spirit; perhaps even your heart...."

Knowing the difficulty Degas had in making up his mind to leave his studio, I was not a little surprised when he informed me that he was going to spend a fortnight with his friend Monsieur Henri Rouart at La Queue-en-Brie.

"I ought to be able to get a few landscapes out of it," he said. "Will you come to see me there?"

I was only too glad to accept his invitation. When I had arrived at La Queue, Monsieur Rouart's gardener directed me to a pavilion, where, on the door-step, I saw an old man with thick glasses, dressed in denim trousers and a straw hat. No one would ever have suspected that this mild figure was the terrible Degas.

"I've been outside long enough," he said, as I approached. "There's still a few minutes before lunch; I'm going to work a little more."

I made as if to go, but he stopped me. "Oh, you can come with me. I'm only doing landscape at present."

I followed him into a little studio he had fixed up for himself on the grounds. He turned his back to the window and began to work on one of his extraordinary out-of-door studies.

I could not get over my surprise at this method of doing a landscape indoors, and when I mentioned the fact, Degas replied:

"Just an occasional glance out of the window is enough when I am traveling. I can get along very well without even going out of my own house. With a bowl of soup and three old brushes, you can make the finest landscape ever painted. Now take old Zakarian, for example. With a nut or two, a grape and a knife, he had material enough to work with for twenty years, just so long as he changed them around from time to time. There's Rouart, who painted a water-color on the edge of a cliff the other day! Painting is not a sport...."

"As I was walking along Boulevard Clichy the other day," I said, "I saw a horse being hoisted into a studio."

Degas picked up a little wooden horse from his work table, and examined it thoughtfully.

"When I come back from the races, I use these as models. I could not get along without them. You can't turn live horses around to get the proper effects of light."

"What would the Impressionists say to that, Monsieur Degas?"

Degas replied with a quick gesture:

"You know what I think of people who work out in the open. If I were the government I would have a special brigade of gendarmes to keep an eye on artists who paint landscapes from nature. Oh, I don't mean to kill anyone; just a little dose of bird-shot now and then as a warning."

But Renoir paints out in the open air, doesn't he?" I queried.

"Renoir is a law unto himself. He can do anything he likes. I have a Renoir in my studio in Paris I'll show you some time. Lord, What acid tones it has!" Degas was suddenly silent, then:

"Renoir and I do not see each other any more," he said.[1]

Just then Zoé came in to announce that there was a visitor outside. It proved to be a lady from Paris who thought she would have a better chance of cornering the painter in the country than in town. She came with a card from Monsieur de V., and old friend of Degas, and her first word was:

"Master!"

"Why 'master'?" returned Degas, with the rudeness characteristic of timid people.

The lady was unruffled, and addressed the painter again as if she were announcing some remarkable news: "My son paints," she said winningly, "and he is so sincere about working from nature."

"And how old is he, madame?"

"He will soon be fifteen—."

"So young and already sincere about working from nature? Well, madame, all I can say is that your son is lost!"

The lady departed quite overcome, as might well be imagined.

VOLLARD: But how is a painter to learn his métier, Monsieur Degas?

DEGAS: He should copy the masters and re-copy them, and after he has given every evidence of being a good copyist, he might then reasonably be allowed to do a radish, perhaps, from Nature. Why, Ingres— […]

VOLLARD: Did you know Ingres?

DEGAS: I was at his house once. I had a letter of introduction to him. I can't tell you how excited I was at the prospect—To think of meeting the great Ingres! Just as I was leaving he was taken with a dizzy spell, and began to reel. Fortunately I was near enough to catch him before he fell.

VOLLARD: Ingres never worked out of doors; but I understand that Manet tried his hand at *plein air*, didn't he?

DEGAS: (irritated): Never say *plein air* to me again! (A pause.) Poor Manet! To think of his having painted the *Maximilian* and the *Christ with the Angels*, and all the others he did up till eighteen seventy-five, and then giving up his magnificent "brown sauce" to turn out a thing like the *Linge*!

VOLLARD: I understand that Courbet could not stand even the *Christ with the Angels*.

DEGAS: Well, for one thing, Courbet contended that, never having seen an angel, he could hardly know whether they had behind or not; and, what was more, in view of their size, they could not possibly fly with the wings Manet had given them[2].But all that talk makes me sick. There is certainly some fine drawing in the *Christ*. And what transparent impasto! What a painter!

[1] AUTHOR'S NOTE: Renoir and I were walking along the Grands Boulevards one day when the conversation turned to Degas. I had heard that Renoir did not like Degas' painting.

RENOIR: Degas liked to mystify people. I have seen him amuse himself like a schoolboy by puffing up a great reputation for some artist or other whose fame, in the ordinary course of events, was certain to perish the following week. He fooled me badly once. One day I was on the driver's box of an omnibus, and Degas, who was crossing the street, shouted to me through his hands: "Be sure to go and see Count Lepic's exhibition!"

I went. Very conscientiously I looked for something of interest. When I met Degas again, I said: "What about your Lepic exhibition?"

"It's fine isn't it? A great deal of talent," Degas replied. "It's too bad he's such a light weight!"

VOLLARD: I've heard Lautrec compared with Degas…

RENOIR: Ridiculous! Lautrec did some very fine posters, but that's about all. … Just compare their paintings of *cocottes* … why, they're worlds apart! Lautrec just painted a prostitute, while Degas painted all prostitutes rolled into one. Lautrec's prostitutes are vicious… Degas' never. Have you ever seen *The Patronne's Birthday?* It's superb!

When others paint a bawdy house, the result is usually pornographic—always sad to the point of despair. Degas is the only painter who can combine a certain joyousness and the rhythm of an Egyptian bas-relief in a subject of that kind. That chaste, half-religious side, which makes his works so great, is at its best when he paints poor girls.

VOLLARD: One day I saw a *Woman in a Tub* by Degas in a window on the Avenue de l'Opéra. There was a man in front of it, tracing an imaginary drawing in the air with his thumb. He must have been a painter, for as I paused I heard him say to himself: "A woman's torso like that is as important as the Sermon on the Mount."

RENOIR: He must have been a critic. A painter would never talk that way.

VOLLARD: Just then a carpenter came along. He also stopped in front of the nude and exclaimed: "My God! I wouldn't like to sleep with that wench!"

RENOIR: The carpenter was right. Art is no joking matter.

VOLLARD: Did you ever have a chance to watch Degas make his etchings?

RENOIR: I used to go to Cadard's, usually after dinner and watch him pull his impressions—I don't dare say etchings—people laugh when you call them that. The specialists are always ready to tell you that they're full of tricks…that the man didn't know the first principles of *aqua-forte.* But they're beautiful, just the same.

VOLLARD: But I have always heard you say that an artist ought to know his craft from the ground up.

RENOIR: Yes, but I don't mean that fly-speck technique they call modern engraving. Some of Rembrandt's finest etchings look as if they had been done with a stick of wood or the point

of a nail. You can hardly say that Rembrandt didn't know his business! It was just because he knew it from start to finish that he was not obliged to use all those fancy tools which get between the artist's thought and his execution, and make a modern engraver's studio look like a dental parlour.

VOLLARD: What about Degas as a painter?

RENOIR: I recently saw a drawing by Degas in a dealer's window—a simple charcoal outline, in a gold frame which would have killed anything else. But it held its own superbly. I've never seen a finer drawing.

VOLLARD: Degas as a colorist, I mean.

RENOIR: Well, look at his pastels. Just to think that with a medium so very disagreeable to handle, he was able to obtain the freshness of a fresco! When he had that extraordinary exhibition of his in 1885 at Durand-Ruel's, I was right in the midst of my experiments with frescoes in oil. I was completely bowled over by that show.

VOLLARD: But what I'm trying to get at is what you think of Degas as a painter in oils…

RENOIR: (interrupting) Look, Vollard. (We had arrived at the Place de l'Opéra. He pointed to Carpeaux's group of the *Dance*.) Why, it's in perfect condition! Who was it told me that that group was falling to pieces? I really haven't anything against Carpeaux, but I like everything to be in its place. It's all right to carry on about that kind of sculpture, since everybody likes it; I don't see any harm in that, but if they would only take those drunken women away and put them somewhere else … Dancing as taught at the Opera is a tradition, it is something noble; it isn't the Can Can … To think that we're living in an age that has produced a sculptor to equal the ancients! But there's no danger of *his* ever getting commissions.…

VOLLARD: Rodin has just had an order for the *Thinker*. And then there's his *Victor Hugo* and his *Gates of Hell*…

RENOIR: (impatiently) Who said anything about Rodin? Why, Degas is the greatest living sculptor! You should have seen that bas-relief of his … he just let it crumble to pieces … It was beautiful as an antique. And that ballet dancer in wax! … the mouth … just a suggestion, but what drawing! What's the name of that old fool … that friend of Degas' who does nudes that look as if they're moulded on a living model – probably are, too … I never can remember names! Well, never mind. He kept after Degas until he finished that mouth, and of course he spoiled it.

METHODS OF WORK

Degas never cared much for money. One of his sayings was: "In my day no one ever really 'arrived.'" And a trace of regret that those days were gone would creep into his voice.

Degas attended an auction at which one of his pictures had fetched a sensational price. As he was leaving, someone said to him:

"Quite a change from the days when you sold a masterpiece for a hundred francs, Monsieur Degas."

"Why do you say masterpiece?" asked Degas sharply. "If you only knew how sorry I am those days are over. I may have been a good horse to bet on, but it is just as well I didn't know it. If my 'goods' have begun to fetch such prices now, there is no telling what Delacroix and Ingres sell for. I won't be able to buy them for myself any more…!"

"But," I ventured, "you could have all the money you want, Monsieur Degas, if you would only dig into your portfolios."

"You know how much I hate to sell my work. Besides, I always hope eventually to do better."

Because of the many tracings that Degas did of his drawings, the public accused him of repeating himself. But his passion for perfection was responsible for his continual research. Tracing-paper proved to be one of the best means of "correcting" himself. He would usually make the correction by beginning the new figure outside of the original outlines, the drawing growing larger and larger until a nude no bigger than a hand became life-size—only to be abandoned in the end.

Degas is said to have remarked to Manet: "I shall be a member of the Institute before you." And when Manet laughed, he added, "Yes, and my drawing will do the trick."

The brilliancy of his pastels has always been considered extraordinary. The painter B. said to me one day: "You know Degas, don't you? Won't you ask him for me where he buys his pastels? My wife is sure there is a trick in the way he gets a

tone which is mat and luminous at the same time."

The next time I went to see Degas he was working in pastel.

"What a devil of a job it is to bleach the color out of pastel crayons! I soak them over and over again, and even put them in the sun...."

I glanced at a pastel on an easel near by. "But how did you manage to get such vivid color in those dancers? They are as brilliant as flowers...."
"That? With the 'neutral tone,' *par-bleu! ...*"

Degas used to say to me from time to time: "Vollard, you ought to marry. You do not realize how terrible it is to be alone as you grow old."

I was telling Degas one day about a birthday party which had been given in honor of one of my grandparents. It was nine o'clock before dinner was finally served. In the excitement grandfather had almost been forgotten, at least so far as his evening mush was concerned, and the result was that the old man had almost died of starvation when a large plate of lobster and *paté de foie gras* was set before him.

"After nine o'clock!" Degas exclaimed in horror. "I'll wager my last sou that they had flowers on the table too."

"Well, they got their idea for the table decoration from a fashionable dinner described by Paul Bourget, and had scattered carnations around on the table cloth. Then one of the little girls said: 'Grandpa, I'm going to let you play with my two little puppies 'cause this is your birthday'."

"Yes," declared Degas, "but I think one could put up with even dogs and flowers rather than to have to endure solitude. Nothing to think of but—death...."

He paused, and I finally ventured to ask: "But what about yourself, Monsieur Degas? Why haven't you ever married?"

"I, marry? Oh, I could never bring myself to do it. I would have been in mortal misery all my life for fear my wife might say, 'That's a pretty little thing,' after I had finished a picture."

DEGAS AND HIS FRAMES

I have already mentioned Degas' reluctance to allow any of his work to go out of his studio because he aspired to do better. This was a great point of pride with him. Another was the frames on the pictures, which he never permitted anyone to change once he had selected them.

When he would finally decide to part with one of his "articles" as he called them, it left the studio already framed, or, in the rare cases where he intrusted his buyer with an unframed picture, he always cautioned him to go to Lézin (the only framer Degas had any confidence in), adding, "I will go over later and choose the frame myself."

He had a special fondness for framing his drawings in *passe-partout* made of a blue paper used for wrapping sugar-cakes. He allowed for a half-inch of space between the edging and the picture. He always said, "None of those bevel-edged mats for me. They detract from the subject too much."

One of his favorite models of frame was "the coxcomb," which had a serrated edge, as the name indicates. He also reserved the right to select the color of his frames, being partial to the bright shades used for painting garden furniture. Whistler called them "Degas' garden frames."

It is easy to imagine Degas' irritation if a collector, believing it would increase the value of the picture, substituted a gold frame for the original which had been selected with such loving care. There was a row inevitably; Degas would refund the money and take the picture back. This happened numerous times. On one occasion Degas had gone to dine with an old friend of his, and as he entered the house, he discovered one of his pictures hanging in the hallway, brazenly decked out in a gold frame. He proceeded to take it down and, after removing it from the frame with the aid of a coin, returned home with it under his arm. His host waited for him to appear, and finally the lady of the house demanded:

"Where is Degas? I thought I heard him coming in a little while ago."

But they never saw him again.

"Never trust a friend," was all Degas had to say about the matter. But meanwhile his "friend" was puzzled over what happened and eventually imagined that the painter had been displeased with the frame because it perhaps had not seemed elegant enough.

"A frame that cost me five hundred francs!" he fumed. "What in Heaven's name does the man want?"

I remarked to Degas that he could feel sure that at least Monsieur Rouart would not change his frames.

"Oh, it's more than just the frame," replied Degas. "The fact is that I never feel really satisfied in letting any of my work go out of the studio...."

But Rouart was not unaware of Degas' artistic conscience. He knew the artist's mania for adding final touches to his pictures, no matter how finished they were. And so to protect himself, he fastened the famous *Danseuses* to the wall with chains.

Degas would say to him: "Now that foot, Rouart, needs just one more little touch..."

But Rouart had no fear of losing his picture; he had confidence in the strength of the chains.

From *Degas: An Intimate Portrait* by Ambroise Vollard, translated by Randolph T. Weaver. New York, Greenburg Publisher, Inc., 1927.

Concise Bibliography

Armstrong, Carol M. *Odd Man Out: Readings of the Work and Reputation of Edgar Degas.* Chicago: University of Chicago Press, 1991.

Bomford, David, Sarah Herring, Jo Kirby, Christopher Riopelle, and Ashok Roy. *Art in the Making: Degas.* New Haven: Yale University Press, 2004.

Callen, Anthea. *The Spectacular Body: Science, Method, and Meaning in the Art of Degas.* New Haven: Yale University Press, 1995.

Clark, T.J. *The Painting of Modern Life: Paris in the Art of Manet and His Followers.* Princeton: Princeton University Press, 1999.

Clayson, Hollis. *Paris in Despair: Art and Everyday Life under Siege (1870–1871).* Chicago: University of Chicago Press, 2002.

DeVonyar, Jill, and Richard Kendall. *Degas and the Dance.* New York: Harry N. Abrams, 2002.

Forge, Andrew, and Robert Gordon. *Degas.* New York: Harry N. Abrams, 1996.

Gross, Jennifer R., Suzanne Boorsch, Susan P. Casteras, Jill DeVonyar, Aruna D'Souza, Susan D. Greenberg, Richard Kendall, and Edgar Munhall. *Edgar Degas: Defining the Modernist Edge.* New Haven: Yale University Press, 2003.

Vollard, Ambroise. *Degas: An Intimate Portrait.* Trans. Randolph T. Weaver. New York: Greenburg Publisher, Inc., 1927.